DATE		

THE CLAY ART OF ADRIAN SAXE

THE CLAY ART OF

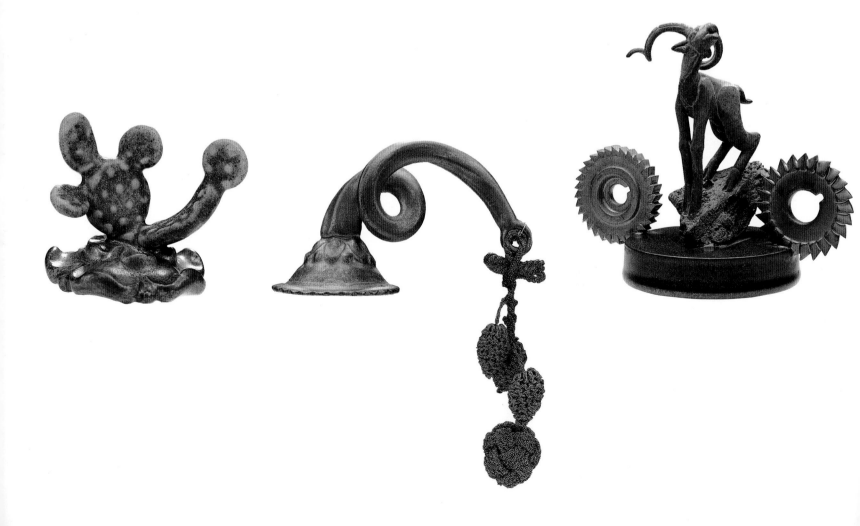

Martha Drexler Lynn

WITH A CONTRIBUTION BY JIM COLLINS

adrian saxe

Thames and Hudson | Los Angeles County Museum of Art

Los Angeles County Museum of Art

November 11, 1993–January 30, 1994

**Museum of Contemporary Ceramic Art,
Shigaraki Ceramic Cultural Park, Japan**

March 20–June 5, 1994

The Newark Museum

July 14–October 23, 1994

Copublished by

Los Angeles County Museum of Art

5905 Wilshire Boulevard, Los Angeles, California 90036

(in the United States)

Thames and Hudson Inc.

500 Fifth Avenue, New York, New York 10110

(in all other countries)

Thames and Hudson Ltd.

30 Bloomsbury Street, London WC1B 3QP

Library of Congress number: 93-85260

British Cataloguing-in Publication Data: A catalogue record for this
book is available from the British Library.

ISBN 0-500-09238-9

The Clay Art of Adrian Saxe was organized by the Los Angeles County
Museum of Art and made possible by grants from the National
Endowment for the Arts and the Pasadena Art Alliance. Additional
support was provided by All Nippon Airways Co., Ltd.

Contents

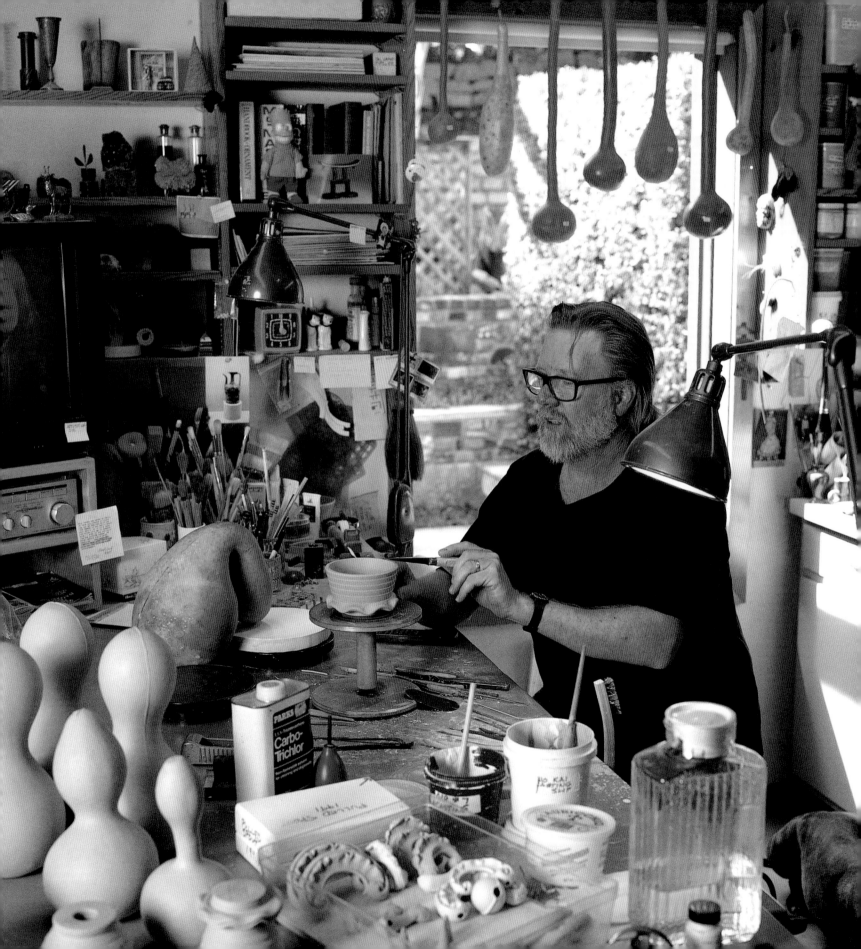

Foreword

Born and raised near Los Angeles, Adrian Saxe was shaped by the city's location on the Pacific Rim and its characteristic blending of social and artistic trends and transplanted European and Asian traditions. The result: engaging and innovative vessels that uniquely combine these diverse influences. Building on historical decorative arts traditions, Saxe creates works that are a mix of both the past and the present.

This examination of Saxe's creations continues the long-standing interest the museum has demonstrated in indigenous talent. Charged with providing an up-to-the-minute review of Saxe's artistic development—occasioned by his fiftieth birthday—*The Clay Art of Adrian Saxe* serves to lay the groundwork for future analyses of his ceramics.

This is the first exhibition mounted by the decorative arts department to travel abroad. After opening in Los Angeles, the show will go to the Museum of Contemporary Ceramic Art in the Shigaraki Ceramic Cultural Park in Shigaraki, Japan, and then to The Newark Museum. The exhibition thus offers an opportunity to share the work of a leading American ceramic artist with a worldwide audience.

I would like to thank Martha Drexler Lynn, assistant curator of decorative arts, for organizing this presentation and writing the accompanying catalogue. I would also like to thank Adrian Saxe for his consistent cooperation and goodwill. His work adds both historical depth and a refreshing dose of humor to the international ceramic landscape.

Michael E. Shapiro

Director, Los Angeles County Museum of Art

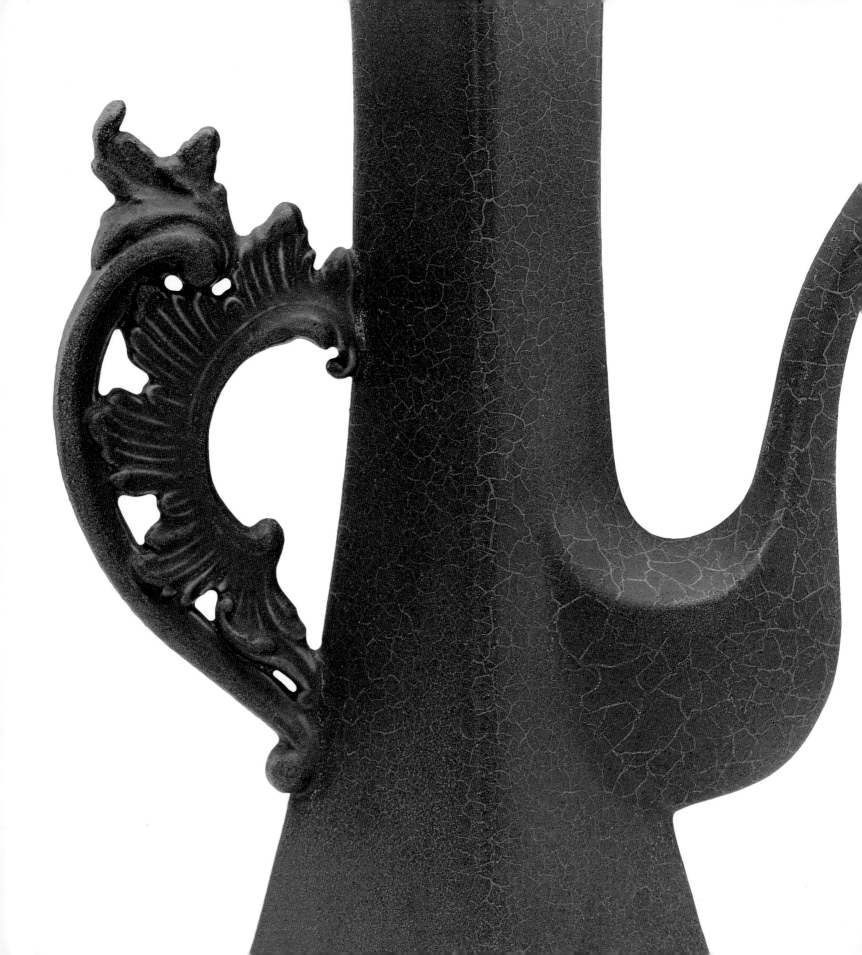

Adrian Saxe
and the
Cultured Pot

Martha Drexler Lynn

Adrian Saxe is a problematic artist. Claimed willingly by neither the ceramics world nor the larger art world, he creates works that appeal to art collectors, sophisticated ceramics aficionados, and artists who understand his "smart pots."[1] Made to seduce and then betray, Saxe's elegant vessels present provocative concepts. While modeled on historical artworks, they are frequently spiced with allusions to popular culture. He presents erudite references to both ceramic and artistic traditions and then delights in undercutting their seriousness with his pervasive humor.

To evaluate Saxe's output, a conceptual understanding of decorative arts history is necessary. That history can be characterized as a progression of steps from function to display. Objects first made for basic use were, over time, embellished with nonfunctional decoration; eventually they were produced in precious materials. As the items spiraled upward in intrinsic value, their role shifted from one of satisfying utilitarian needs to that of display and status.

Whether utilitarian or for display, the decorative arts have been artificially separated from the fine arts. Beginning in the eighteenth century, this process allowed the former to be seen as inferior to works executed in such sanctified mediums as paint on canvas, bronze, or stone.[2] During the nineteenth century this denigration of craft-based works was sped along by the growth of machine-made objects and the aggrandizement by makers, dealers, and collectors of the so-called non-functional arts of painting and sculpture.

During the twentieth century the connotations of the word *function* were again examined.[3] Notions regarding the nature of art and craft were transformed by an increased acceptance of non-traditional media as appropriate materials for artistic expression. Clay benefited the most, as it historically had been functional, decorative, and/or aesthetic.

9

Saxe's vessels are rooted in both a historical and contemporary vision of the decorative arts. While utilitarian, their craftsmanship and beauty render them suitable for display and contemplation. By the successful linking of decorative arts traditions, studio ceramics processes, and artistic content, he turns his utilitarian-based medium into a vehicle for philosophical musings. Although the success of his objects rests on craft skills expressed in a craft medium, he uses only enough technical "sleight of hand"[4] to create works that accomplish his mission of reaching beyond craft considerations to make serious statements about both ceramics and art. Pushing the boundaries of accepted good taste, reaching in some later works the vulgarity of a "Tijuana tuck and roll interior,"[5] he uses craft as a strategy only, not as a goal. By combining ceramics traditions and expectations with wit, insight, and nuances from the larger art world, Saxe transforms his vessels into sculpture.

[49] *Page 8*

La Tour Akan (detail)
1984

On February 3, 1943, Adrian Anthony Saxe was born to Adrian and Dorothy Saxe in Glendale, California, a suburb of sprawling Los Angeles. Called Tony as a child, Saxe was exposed to popular and commercial art by his mother, who worked as a cel colorist for the Walt Disney Studio in Burbank. His father, a licensed embalmer, worked on and off as the foreman at Forest Lawn Mortuary. The senior Saxe was also interested in photography and would later support his family with this skill. Both mother and father taught their son craft techniques and respect for artistic, handmade objects.

Exposure to Hollywood theatricality came as Saxe helped deliver the Pacific Coast Studio Directory (begun by his paternal grandfather) to subscribers. The dramatic world of movies and the nascent television business made Saxe aware of the value of grand gestures as effective communicative tools. These

early experiences established for him a bedrock interest in art, craft, and idiosyncratic expression.

In addition to reading *Mad* magazine, running his paper route, and collecting interesting rock formations, Saxe experimented with the earthenware clay he found in his backyard. His early artistic endeavors earned him a scholarship to the Otis Art Institute in Los Angeles in the summer of 1957. There he was drawn to drawing, but due to scheduling problems the subject was not offered at his grade level. Ceramics was, however, so he entered that class instead. Although not exposed to sophisticated clay techniques there, he did glimpse a larger world through instructor Priscilla Beattie's passionate evocation of travels to far-off lands. In 1959 she took Saxe to see the design section of an American Ceramics Society exhibition that featured Peter Voulkos. Voulkos's powerful creations vividly illustrated that clay could go beyond utilitarian function. In 1960 a sculptural work by Saxe won a national award after first winning a regional contest sponsored by Bullock's of California, a local department store.

Although his first ceramic success was in sculpture, Saxe also took an interest in utilitarian pots. At the time the prevailing concern was for the humble vessel tradition extrapolated from Japanese folk pottery. Local artisans Laura Andreson and Susan Peterson, known to Saxe through their work, represented the pervading crafts dogma that valued morality and process over external style.[6] The only other accepted mode of clay expression was the academic sculptural realism practiced by Millard Sheets at Otis. This was all to change, however, as Voulkos's aggressive vessel interpretations overturned conventional ceramics expectations.

Saxe liked school and did well in all the empirical sciences. Chemistry was of particular interest; he was good enough at it to serve as a lab assistant in high school. When Adrian, as he then was called, instigated his family's move to Hawaii by waxing eloquently about the joys and opportunities available in the island paradise, he attended the state university, majoring in inorganic chemistry and minoring in art.

Adrian Saxe, Kealakekua, Hawaii, 1962 (photographed by his father)

Again attracted to the ceramics department, with its international circle of students and potters, Saxe saw porcelain teawares made by Japanese ceramist Omori Terushige. Intrigued by the Japanese glazes but unchallenged by the forms, Saxe was introduced to yet another side of the Japanese aesthetic. Here he saw little compositions, made with great finesse, assume an importance beyond their size. This glimpse of the potential power inherent in small-scale works was a revelation to him.

Of equal interest was the vigorous style of ninety-pound Harue McVey. Although small, she could throw huge claywares without resorting to the bravado and swagger made popular by Voulkos. Watching her work demonstrated to Saxe the value of control, concentration, and skill.

After a year at the university Saxe decided that art was his main passion. He dropped the chemistry classes and focused on art courses. He also met Orville Clay, a former teacher who shared Saxe's interest in ceramics. In 1962, after a second, less-happy academic year, Saxe left school and toured Hawaii with Clay, eventually returning to California with him to set up a ceramics studio in Costa Mesa. In order to continue working in clay, Saxe fabricated throwing wheels patterned on the "Ohio State University design" by combining stock plywood, salvaged steel bearings, truck tire rims, side foot treadles, and connecting rods.[7] Made as they were from surplus supplies, they could be constructed for half of what commercially made wheels cost. With money a constant worry, this skill at improvising helped to bridge the gap between wanting and having the necessary tools for work. It also left Saxe with an abiding love for mechanical imagery.

In this first studio Clay and Saxe made lamp bases, mugs, table pottery, and bottles. Clay enjoyed making decorative pieces and did not have large artistic ambitions for his work. Saxe, however, wanted to continue his sculptural explorations and to sell his wares in the few galleries that presented clay. In 1963, after some limited success, he and Orville exhibited their efforts at the Albatross Gallery in

Balboa, California. Saxe also had a one-man show at Orange Coast College. Some months later Clay returned to Hawaii.

At this time Saxe decided to join the Voulkos group that had been established in Berkeley during the early 1960s. While working as an olive tree spotter to earn money for the move, however, Saxe suffered a debilitating auto accident. Incapacitated for several months and unable to make art for almost a year, the opportunity to join Voulkos passed.

The auto accident led to two key decisions. First, Saxe decided to devote all his time to art. This meant only taking jobs that related in some way to ceramics. Second, he decided to reenter school at Los Angeles City College to straighten out his academic record.

In retrospect the accident was fortuitous, for the Voulkos energy was past its peak[8] and a new spirit in ceramics was developing. Espoused by Jim Melchert and Richard Shaw at the San Francisco Art Institute and Robert Arneson at the new ceramics department at the University of California, Davis, the Northern California funk ceramics movement was taking hold.

Saxe received further training when he entered Chouinard Art School in 1965 and began studying ceramics under Ralph Bacerra and art history under John Coplans. Other influential professors were Jules Langsner and abstract classicist painter Fred Hammersley. While free to focus on a particular medium, most art students at Chouinard experimented outside their chosen specialty. This created an atmosphere in which exploration was encouraged and boundaries between the applied and fine arts were crossed.

Chouinard was a peer-driven setting with a community of older and younger artists. Saxe's group included Terry Allen, Chuck Arnoldi, Ron Cooper, David Deutch, Guy Dill, Laddie John Dill, Jack Goldstein, Susan Karrash, Juanita Jimenez Mizuno, Mineo Mizuno, Elsa Rady, Peter Shire, George Wight, and Tom Wudl. At Chouinard the completion of an academic degree was not the main goal; the gaining of enough empirical knowledge to be a practicing

ceramist was. For older students such as Saxe, being there was a matter of choice and passion.

Saxe also labored as a lab assistant. For his own ceramics work he set up a space with Wight and Rady in Hal Fromhold's studio on Second Street in downtown Los Angeles. Equipped with jury-rigged kilns and wheels, it allowed Saxe to continue making sculptural ceramics. At school he explored pottery forms.

Always aware of trends within both the ceramics world and the larger art world, Saxe became a willing participant in the crafting of works with visual and verbal puns, a funk characteristic. Making casually crafted, hand-built, raku pies, he gave them punning and arch titles: *Pie-ku*, 1967 [1]*; *Python-U*, 1967; *Pie-in-the-Sky*, 1967; *Cow Pie: Udderly Delicious*, 1968 [2]; and *Hair Pie*, 1968 [3]. Each of these demonstrated his early interest in kitchen and food metaphors; some, his youthful passion for sexual innuendo. They also contained two Saxe hallmarks: a penchant for layered references and a deftly whimsical hand.

With finances always precarious, he supplemented his income by working for the Franciscan Group at Interpace China Corporation in Glendale. Following the example of Susan Peterson, who taught across town at the University of Southern California, Saxe, Rady, Shire, and Mineo Mizuno worked at Interpace for both the experience and the exposure to factory methods of production. There Saxe learned about low-fire glaze technology and augmented his vocabulary of glaze colors and textures. Trained by Bacerra in earthenware and stoneware studio techniques, he expanded his technical skills during the time spent at the factory.

Passionate about all artistic expression, Saxe attended local gallery openings and was familiar with contemporary art theories. In 1966–67 the "Los Angeles look" or "fetish finish style" (disparagingly named by the New York cultural elite) was the latest rage. Making work that was in direct contrast with that of the Bay Area funk group, fetish finish artists were interested in abstractions fashioned out of commercial materials, including fiberglass and resin. Sporting glossy and impersonal surfaces, the works were supposed to look machine made, the opposite of the

Bracketed numerals indicate catalogue numbers. The checklist provides illustrations of all works so designated.

Japanese folk tradition prized earlier. Ken Price painted the surfaces of his ceramics instead of glazing them, labeling the creations with "techno"[9] titles. He and Billy Al Bengston also explored the nature of connotations inherent in the precious object. Both of them, along with Larry Bell, Robert Irwin, and John McCracken, although not a cohesive group, showed at the influential Ferus Gallery as well as the Irving Blum and Nicholas Wilder galleries in Los Angeles.

Saxe was especially impressed with the leaning, fiberglass, surfboardlike slabs made by McCracken. Conceptualized as enlivening both the floor they sat upon and the wall they rested against, they exploited the interaction that occurs between an artwork and the space it occupies. Saxe was quick to transfer this concept to clay. The result was a series of ceramic domes [4]. These wall-mounted, porcelain, mold-made forms were surfaced with shiny commercial glazes and were designed to punctuate space in arrays both random and linear in groups from nine to more than thirty (FIG. 1). While certainly aware of Judy Chicago's plastic domes, Saxe's idea was derived from MEM (FIG. 2), a mathematical game that uses thirty-two plastic discs, called stones. This table game involves the building of patterns that "represent" other patterns and is touted as a way of developing abstract thinking and "a new awareness of symbols and their function."[10] The brightly colored MEM stones, each about one inch in diameter, were transformed by Saxe into the large three-dimensional domes. While successful in activating the wall space and expressive of the techniques learned at Interpace, they were one-line conceptual pieces that lacked the humor usually associated with his work.

Continuing his exploration of forms and methods,[11] Saxe ransacked the hobby world for luster glazes. Although Patti Warashina and Fred Bauer, working in the Pacific Northwest, also drew on this source, Saxe added his own innovations by ignoring product instructions and applying materials as whim directed. Although this resulted in some disasters, it also led to new uses and dazzling effects. Additionally, it crystallized his interest in knowing enough technique to accomplish what he wanted without making his works sodden with technical fastidiousness.

FIGURE 1

Adrian Saxe and ceramic dome
wall sculpture
c. 1971
Copyright © 1971, California
Design, Pasadena

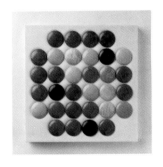

FIGURE 2

MEM
Copyright © 1968, Stelledar
Inc., Philadelphia

The domes also started him on an exploration of the potential of mold-made forms.[12] Other ceramists working with molds at the time derived theirs from hobby sources; Saxe did too but also made some from found objects. His eventual interest would lie in extrapolating from nature to create imagined articles.

A number of Saxe's early pieces were derived from Chinese bronzes and lacquerwork. He was drawn to the additive approach to form creation seen in traditional Chinese vessels. In 1968 he viewed the traveling exhibition *Chinese Treasures from the Avery Brundage Collection*, which was organized by the M. H. de Young Memorial Museum in San Francisco. Most impressive to him were the Song ceramics (960–1279) and Shang bronzes (1523–1028 B.C.). Concepts seen in this show would appear in later compositions.

In his next body of work Saxe explored light and the activation of space through reflection, concerns parallel to those of the Los Angeles light and space school. The Huladicks and Lollycocks linked these sensibilities with his funk aesthetic. The mold-made *Lollycock (Dento)*, 1968 [5], is a phallic form that was executed in a high-gloss glaze and mounted on a base with a Plexiglas cover. The metallic finish on the upper half reflects and "activates" the base and the surrounding space. In *Huladick (Lavender)*, 1969 [6], a similar form sports a shimmering, metallic "hula skirt" made of clay tendrils. These works owe their high-gloss surfaces to the fetish finish school and their crude language to the freedom of funk. They are also an early expression of Saxe's interest in the power of "display postures"[13] and in the deft use of off-color humor to titillate his audience.

Saxe continued through the early 1970s to make plates, mugs, covered boxes, and casseroles to survive economically. While grounded in utilitarian concerns, they were more elaborate than necessary and as such revealed the direction he was headed. His porcelain mugs [7] were conceptualized with a high modernist attention to function. Tall and slender and made in linked "colorway" batches of twelve to twenty, they have small evaporative surfaces and an attractive heft. While Saxe sold them as utilitarian wares, they doubled as glaze tests. The shallow bowls [8],

[5]

Lollycock (Dento)
1968

17

made from 1972 through 1979, show his interest in unusual decorative devices. In this case he incorporated saw blade edges as rims. In *Covered Bowl (Nut Dish)*, 1972 [9], the title reinforces the visual pun. Other works of the period included covered vases with semifunctional finials in flower or insect (grasshopper and cicada) shapes. By placing slightly off-putting or unexpected elements together, he introduced a tension between implied functionality and assumed form expectation. This is a theme he would return to often.

During this period Saxe discovered, while alternating between making earthenwares, stonewares, and porcelains, that he could sell porcelain plates for forty to eighty dollars, seven to ten times what he could get for earthenware or stoneware ones. Soon he was making porcelain vessels exclusively. Although this decision was pragmatic, it was also rebellious. Porcelain was out of favor in the American ceramics world of the late 1960s and early 1970s. Not only difficult to work, it also had overtones of preciousness and elitism, qualities disdained by the humble studio potter. It was precisely these aspects that interested Saxe, however.

Also out of step with his peers was Saxe's interest in historical vessel conventions and the limitations they imposed. He found them more challenging than the free flow of self-conscious sculptural clay favored by the abstract expressionists and the funk artists. Information about historical forms was not readily available, however. In Glenn C. Nelson's *Ceramics: A Potter's Handbook*, the standard text about historical clay available at the time, Chinese court porcelains of the Song and Ming (1368–1644) periods are only briefly mentioned.[14] Saxe's discovery of a 1944 copy of Warren E. Cox's *The Book of Pottery and Porcelain* was thus a godsend. Although the book's photographs were small and fuzzy, Cox presented a complete history of world ceramics, picturing everything from primitive vessels to arcane court porcelains. Judged by Cox from a decorative arts perspective, not that of a working potter, personal opinions were offered on the merit of the works. Illustrated with utilitarian shapes placed alongside images of decorative garnitures, the book promoted fruitful flights of fancy into imagined historical forms. Saxe also turned

to the historically based volumes by William Bowyer Honey on the European and Chinese ceramics at the Victoria and Albert Museum in London. With these ceramics references to draw upon, Saxe began to learn the history of utilitarian conventions.

Actually seeing historical works proved to be the most instructive experience, however. For Saxe this occurred at the Henry E. Huntington Library and Art Gallery in San Marino, California. Often going there to visit Constance Dienz (his future wife), who worked as a gardening assistant, Saxe regularly saw fine eighteenth-century court porcelains.[15]

This exposure to historical ceramics fed Saxe's interest in the concept of "simulacrum." Defined as the practice of taking an object's visual identity and transforming its meaning through incomplete, even dishonest re-presentation, this concept was vividly articulated by French theorist Jean Baudrillard in the 1970s.[16] For Baudrillard the quintessential example of operative simulacrum was Disneyland, where famous locales, such as the Swiss Matterhorn, are re-created and presented at a reduced scale. While not intentionally dishonest, this transformation diminishes the original content (indeed, it is the scale of the mountain that makes it impressive), rendering the Disneyland version kitschy and harmless. This notion intrigued Saxe. From then on he applied it to clay by bringing historical forms forward in time with newly assigned meanings. This became a hallmark of his work.

This concept had already been observed by Saxe at the *Art Treasures from Japan* exhibition at the Los Angeles County Museum of Art in 1965. The show contained a range of media, including clay. Particularly appealing was the work of Aoki Mokubei, an Edo-period ceramist. Known for his inventive integration of disparate forms, Mokubei was intentionally eclectic and delighted in melding form vocabularies from a number of cultures. Again, here was simulacrum in practice. Saxe later developed a similar approach by linking historical Chinese forms to European court wares, lacing them with contemporary pop imagery.

In 1971 Saxe was asked by Dr. Robert Wark, curator of the Huntington, to submit jardiniere designs for the galleries and room settings. Meant for inconspicuous

placement next to the court furniture and porcelains, their main objective was utilitarian function. After hours spent reviewing the eighteenth-century collections, Saxe presented a Georgian-inspired shape with hand-modeled, applied rams' heads [10]. Upon review, Wark deemed them too assertive and requested that they be made without the embellishment and glazed in subdued earth tones. Saxe complied and produced thirty small ones and two large ones. Many of them are still in use in the Huntington galleries.

While working on this commission, Saxe examined the Huntington's Chinese Cizhou and Song Ding ware court porcelains in ormolu mounts. He was intrigued by the complexity and sophistication of their display techniques. Ceramics framed by fittings of silver toned with gold fired Saxe's interest in concepts of preciousness, reassemblage, and the power of presentation rituals. The Ming porcelains and polychrome stonewares also impressed him. Related vegetable shapes adapted from Chinese ewers later appeared in his work.

Saxe also studied the English Wedgwood Creamware and Chelsea Red Anchor pieces. Creamware, Wedgwood's trade name for its tin-glazed earthenware, was invented to meet the English middle-class demand for costly porcelains. While made of earthenware, its cream-colored glaze was suitable for the application of decorative patterns. With its pleasant color, potential for ornamentation, and allusions to porcelain, the line was a commercial success. Pandering to middle-class tastes for specific forms for specific functions, Wedgwood created many pieces for limited uses. This concept captivated Saxe and eventually led him to make his own designs for esoteric function. Among these were his vases for epiphytic plants. Unfortunately, the function was too specific and the purchasing public too limited.

The Chelsea Red Anchor ware on display at the Huntington presented a quirky inventiveness of form. The gold-based glazes, in reddish shades, were used in numerous decorative ways to meld disparate and often incongruous shapes. Such virtuosity in combining different forms and designs inspired Saxe to attempt the same.

He was also attracted by the fine soft-paste Sèvres porcelains, the core of the Huntington's eighteenth-century ceramic collection. Sèvres soft-paste porcelain (fired at a lower temperature than hard paste) was valued for its luminous appearance. The surface, which allowed the melding of pigments to the clay, had a visual softness not found in other types of porcelain.[7] The Huntington's holdings displayed the characteristic Sèvres traits of delicate painting and skillful gilding. For Saxe, the inspired ability of the French craftsmen to concoct unique approaches to decorative devices and to create original shapes was the most remarkable attribute of the works.

Of particular interest was the Huntington's soft-paste garniture *Set of Three Vases*, 1758 (FIG. 3). The set was made to commemorate the Battle of Fontenoy, fought in 1745. The central vase features a scene from the conflict. Decorative flourishes garland all of the vessels in vivid pink and green on a pure white ground. The forms are quirky and inventive, with cannons protruding from turrets on the tower vases and scrolls that become goats' heads.

In other of the Sèvres pieces at the Huntington, decorative techniques such as the *vermiculé* (worm-shaped) pattern captivated Saxe. Found, for example, on the *Pair of Fan-Shaped Vases*, 1758, this design was used to decorate the area between the painted and gilded panels. Similar forms, rendered three-dimensionally, would later appear in his work (see [68]). A vase from the J. Paul Getty Museum (FIG. 4) illustrates the type of vermiculé ornamentation that inspired him.

Exposure to the Huntington collections led to significant innovations in Saxe's work. First among these was the addition of animal forms to his decorative repertoire. He had studied animals at the Los Angeles Zoo in conjunction with his work at Chouinard and then for the Huntington jardiniere commission. Elephant, ram, goat, and antelope shapes also developed from his interest in eighteenth-century metalwork and trophy designs.

Animal (and sometimes plant) forms were used by Saxe as alternatives to the human form, as a way to avoid traditional figurative associations. Animals

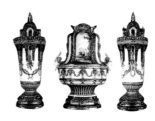

FIGURE 3

Manufacture Nationale de Sèvres, France
Set of Three Vases
1758
Porcelain, enamels, and ormolu mounts
Height (not including mounts): center vase, 19 in. (48.3 cm); tower vases (each), 20 in. (50.8 cm)
Henry E. Huntington Library and Art Galleries

FIGURE 4

Manufacture Nationale de Sèvres, France
Vase (rear view)
1761
Porcelain and enamels
5⅞ x 9¹/₁₆ x 4¹¹/₁₆ in. (14.9 x 23.0 x 11.9 cm)
Collection of the J. Paul Getty Museum, Malibu, California

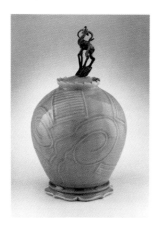

represented a natural force that could be placed in potent opposition to culturally mitigated vessel forms. In *Untitled Covered Jar*, 1972–73 [11], for example, a cylindrical stoneware vessel has curled elephant trunks serving as uneasy handles. The body, covered with an unglazed, patterned and carved slip, contrasts with the smooth, glazed celadon of the lid. The surface treatment of the jar, resembling that of an African leather shield, is a parody of Hollywood's exoticism when styling familiar objects.

Saxe eventually settled on the antelope as being the most expressive symbol of nature's wild energy. The *Untitled Covered Jar with Antelope Finial*, 1971 [12], a classical, globular, lidded jar, is an early example. The animated, naturalistic finial is consciously oversized, considering normal expectations for handles on similar forms, but its utilitarian function is still immediately recognizable. *Untitled Covered Jar with Antelope Finial*, 1973 [13], is a slab-constructed, straight-sided, Islamic-tile-patterned porcelain vessel. A hand-modeled eland rises tentatively on the wheel-thrown lid. Playing with images of the hunt and the aura of privilege that blood sport implies, Saxe integrated forms derived from the disparate cultural spheres of European heraldry, Chinese vessels, and Islamic patterning. Additionally, by making the fragile eland an uneasy finial, Saxe, fully in control of his concept, deftly undercut vessel conventions and functional expectations. The animal's awkward vulnerability contrasts with the solid vessel below.[18] A similar theme is seen in the *Untitled Covered Jar with Antelope Finial*, 1979 [14], and *Untitled Covered Jar with Antelope Finial*, 1979 (FIG. 5).

As seen with the antelope jars, Saxe creates in a circular fashion, not thematically or chronologically. Once a form enters his repertoire, he continually experiments with it, returning, sometimes after years, to try out new techniques. This catalogue groups similar shapes instead of arranging them in a strict year-by-year fashion. It also generally orders his output based upon form explorations undertaken before and after 1983–84. These divisions, while artificial, provide a way to trace his loopy working style.

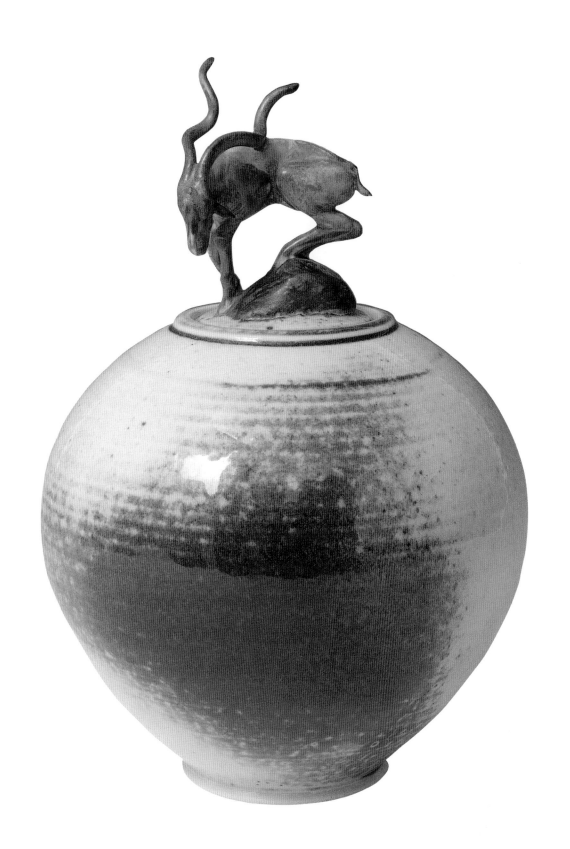

Continuing his interest in the activation of space first explored in the domes, Saxe next turned to developing oil lamps. *Untitled Oil Lamp*, 1972 [15], is a tall design that is shaped like an angular flame. Imposing in height, it contrasts with the *Small Cactus Oil Lamp*, 1977 [16], and *Small Brown Cactus Oil Lamp*, 1977 [17]. Slab-built and often topped with hand-modeled cactus sprigs,[19] the oil lamps seemed to dance and sway in concert with their flames. These seemingly minor works ("goofs"[20]) can be seen, in retrospect, as important explorations into later constructions (the torso jars).

Saxe returned to these lamp forms over the next sixteen years. Constantly curious about their every aspect, he even modified the mechanical design and invented a special ceramic burner.[21] Over time he created new shapes, including shoes, fish, and vegetable (especially chili) forms. In *Untitled Oil Lamp*, 1983 [18], the oil burner is housed in a cylindrical form rising out of a ball, which is balanced precariously on a slab of stoneware. This asymmetrical arrangement sits on top of an elegant porcelain teapot base, which contrasts absurdly with the raw stoneware. In *Untitled Oil Lamp (Chili)*, 1985 [19], and *Untitled Oil Lamp (Chili)*, 1986 [20], a free-form stoneware base is ingeniously combined with a stern geometric form topped with a naturalistic porcelain chili pepper. These works involve the sophisticated manipulation of divergent three-dimensional forms and illustrate Saxe's abiding interest in sculptural issues. In the late 1980s he again returned to oil lamps. This time he used narrow fish-shaped forms placed on scrolled bases [21–22]. The demanding presence of these pieces is markedly different from the intimate early works.

Saxe was asked in 1973 to substitute at the University of California, Los Angeles, while ceramics professor Edward Trainer was on leave. Saxe hoped this would be a studio teaching job and that Trainer would return to do the paperwork. Instead, it became a full-time position. Like other teaching artists, Saxe found that this involvement, although a drain on his artistic time, also allowed for constant reevaluation and exploration of creative territory.

[16–17]

Small Cactus Oil Lamp
1977
Small Brown Cactus Oil Lamp
1977

[19] *Page 26*

Untitled Oil Lamp (Chili)
1985

[22] *Page 27*

Fish Oil Lamp
1988

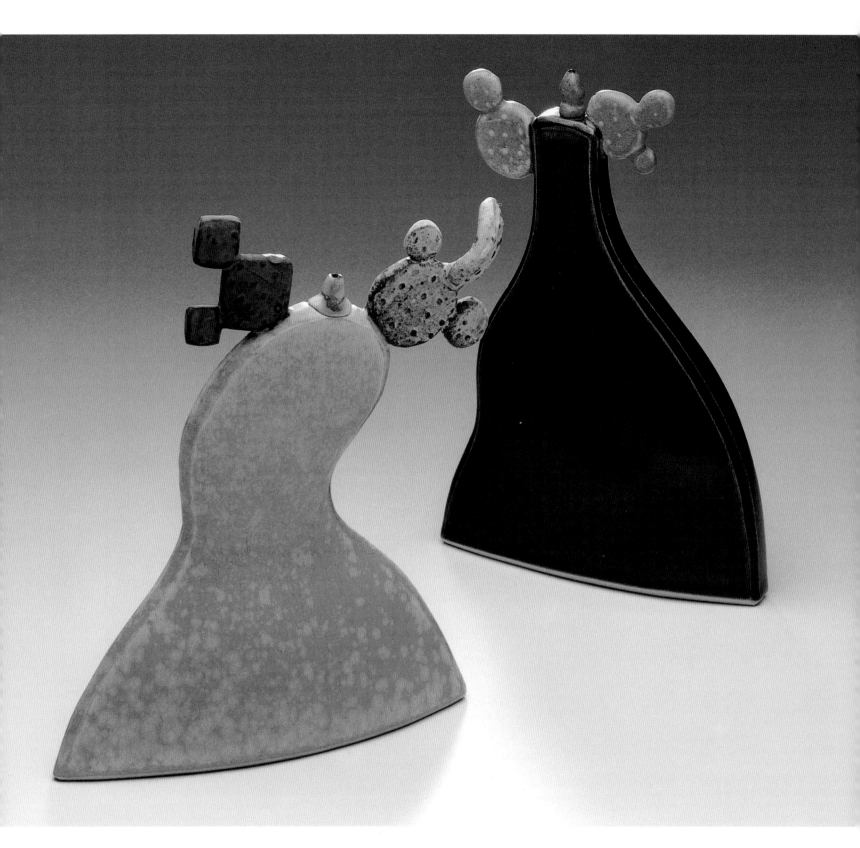

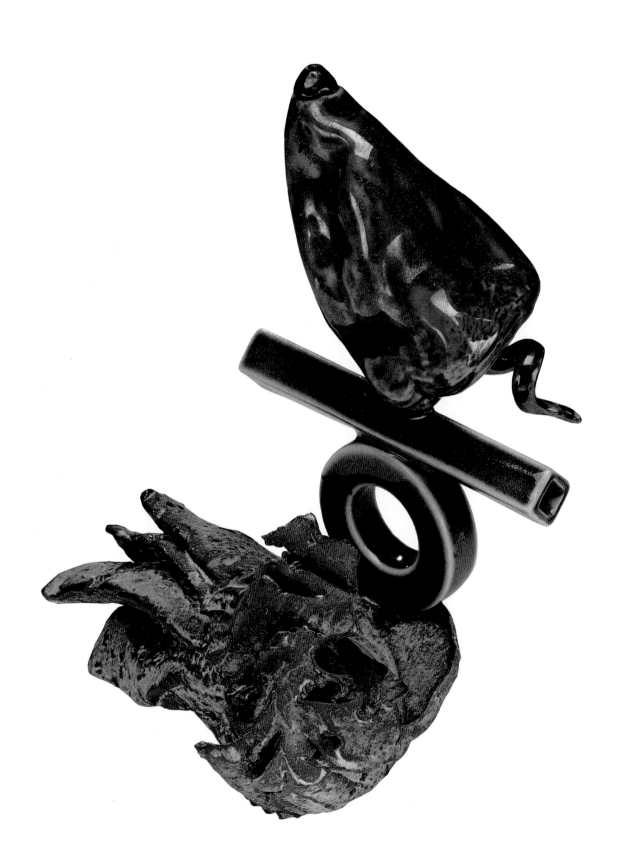

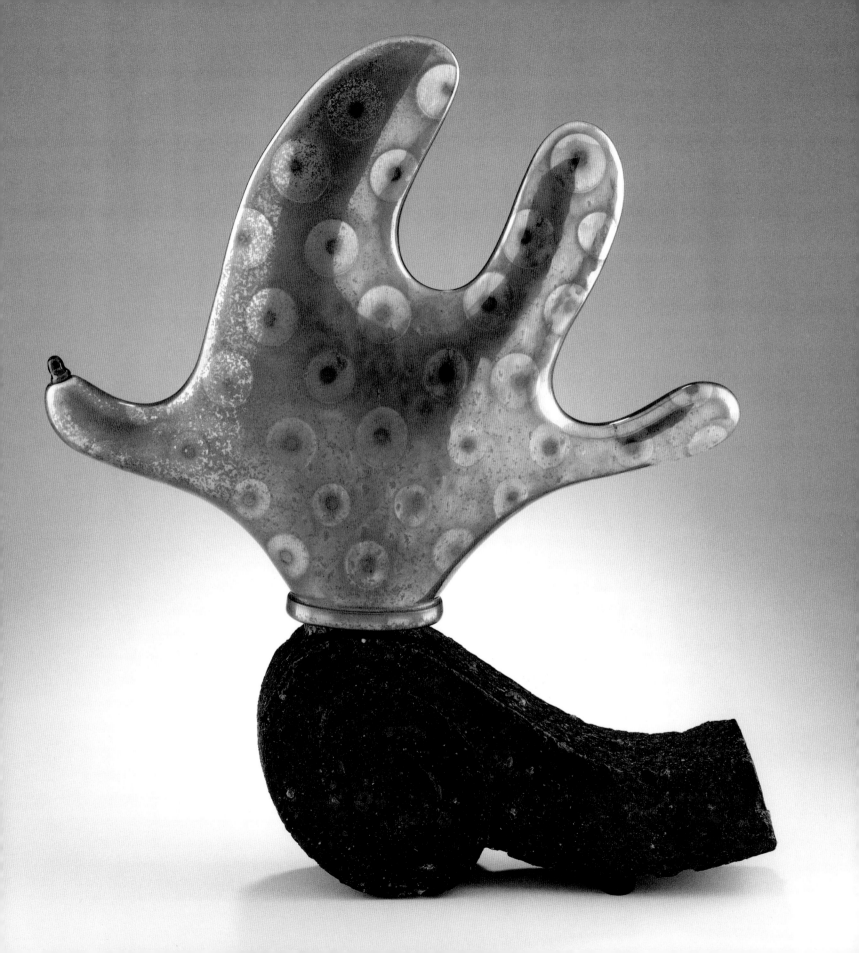

Marking a return to the antelope jar format but with a twist that presaged the torso form that Saxe would later explore is the slab-built *Untitled Covered Jar on Base with Antelope Finial*, 1976 [23]. Placed on top of a plinth—made of rubble masonry—with clearly defined edged sections, the rectangular jar rises in a *bombé* form covered with clay reeding. Sticks of colored and extruded clay were luted to the underlying body in a chevron pattern banded with contrasting beading. Applied clay *kamaboko* (Japanese rice-forming) dies in crescent, heart, spade, and various other shapes poached from aspic molds provide a relief from this obsessive decoration. Twists of beading form earlike handles; the oval lid is surmounted by a standing antelope.

In the late 1970s bottle shapes attracted Saxe's interest. Fascinated by the possibilities for presentation, he combined curvaceous stoneware or porcelain bottles with squared raku plinths, as in *Bottle and Stand*, 1979 [24]. At first a presentation base seemed necessary, a result of seeing the Huntington's eighteenth-century Sèvres works in their nineteenth-century mounts and because of the Chinese tradition of placing precious objects on wooden supports. Later he realized that his bottles could stand on their own or be integrated with their bases.

Bottle and Stand, 1979 [25], is decorated with four contrasting textures and colorations of glaze. The handles assume an importance as they soften the strict verticality of the neck and emulate the curve of the turquoise base, which was inspired by the Chinese adaptation of the chrysanthemum. *Bottle and Stand*, 1979 [26], and *Bottle*, 1980 [27], are similar in format but have smaller handles. Table sized and wheel thrown, with slab-built and press-molded pieces, all of the bottles look like small reliquaries, standing totemically straight and centered.

The saw blade edges Saxe had applied to his shallow bowls (see [8]) found new expression in the cauldrons (so named because of their wide girths). What seemed too sinister for the bowls worked well in this new format. These gear-

[25]

Bottle and Stand

1979

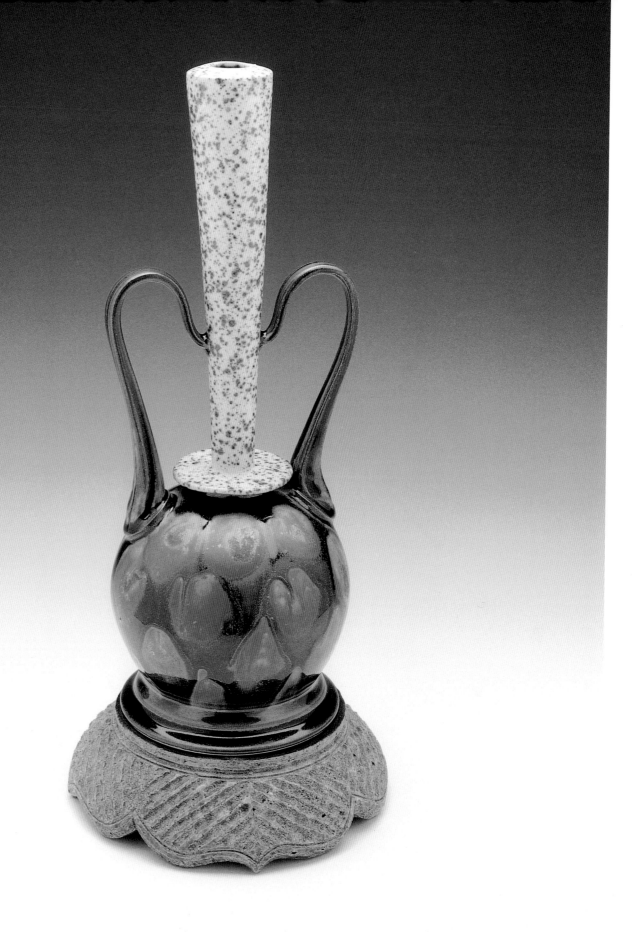

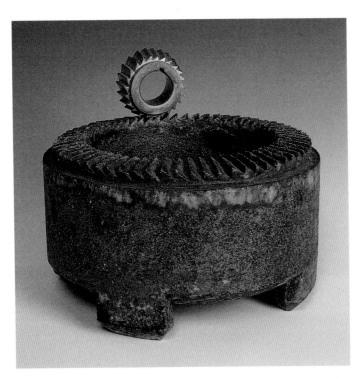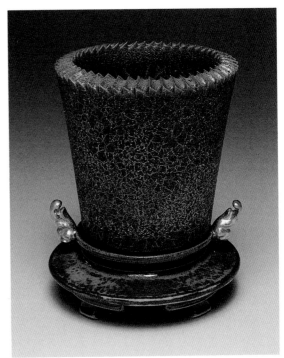

edged pieces were executed both in porcelain [28–29] and heavily grogged stoneware [30]. Saxe modeled his gears on side milling cutters illustrated in the 1938 *Pratt and Whitney Small Tools* catalogue (FIG. 6). A seemingly incongruous idiom for clay, they added a note of tension by expanding concepts of appropriate decoration. Carved by hand to avoid cold mechanical perfection, the poised gears were intended to imply the potential for rotational movement.[22] They also opened up an investigation into issues of form, juncture, and material integration.

Next Saxe examined the bowl and stand format. Again wrestling with issues of presentation, first toyed with in the Huladicks, he based this series of works on the utilitarian mortar and pestle. Intrigued by the sexual imagery implicit within the form, he also wanted to explore the audience interaction explicit in the object.[23] The pestle proved cumbersome and confusing to the viewer, however, and was soon dropped, leaving Saxe to concentrate on the bowl and stand.

Derived from Chinese court porcelains, the early bowls and stands are small and jewel-like. Standing only a bit over five inches high, *Untitled Mortar Bowl with Stand*, 1981 [31], is typical of this form. The beaker-shaped bowl has a serrated edge and sits on top of a base reminiscent of teak display stands. Two curved scrolls stand out from the base to function visually as handles. The clear frontality and richness of the glaze texture declare the importance of this tiny, precious vessel.

Saxe also tried a round-bottomed bowl and stand arrangement, and with it he reached a new sculptural purity. At first the stands were made of raku concocted from crushed kiln losses. These followed traditional decorative arts forms (see [32]). Later bases were manipulated to resemble molten clay torn from the earth. With their actual and metaphorical genesis, they reinforced the thematic exploration of the hierarchy of materials and the meaning of preciousness.

The bowls and stands range in size from small (6¼ inches high; [33]) to large (17 inches high; [34]). Rugged, lavalike raku bases, enlivened with inclusions of copper filings, are topped with simple bowls made ominous by their serrated edges.

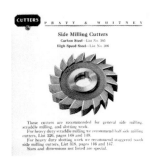

FIGURE 6

Side Milling Cutters
Detail of page from *Pratt and Whitney Small Tools*, catalogue no. 15, 1938
Photographed with the permission of Cincinnati Milacron Marketing Co.

[30]

Untitled Mortar Bowl
1981

[31]

Untitled Mortar Bowl with Stand
1981

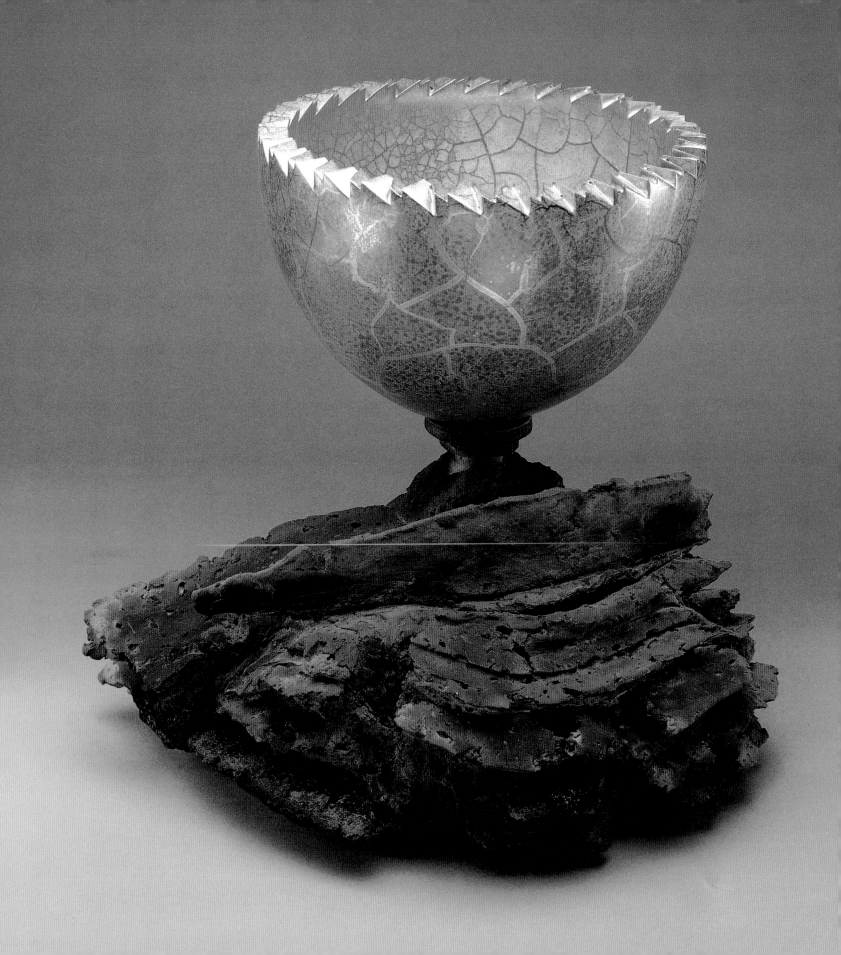

Glazes range from bright gold to platinum with a delicate crackle or heavy veining. The cups recall chalices or relics fashioned for the celebration of pagan rites.

Saxe not only used variations of scale and surface treatment to establish the different moods for each piece but also explored issues of juncture and proportion. In *Untitled Mortar Bowl with Stand (Big Red)*, 1987 [34], the bowl, smaller than the base, is delicately perched on a disk. This successful joining of contrasting materials and forms is accomplished through a small touch point. Mismanagement of this juncture would destroy the balance and make the piece look forced. In *Untitled Mortar Bowl with Stand (Boudin Noir)*, 1987 [35], Saxe returned to the evocative food associations first seen in the raku pies (*boudin noir*, literally "black pudding," is a type of blood sausage enclosed in an intestinal casing). Here the scale is large; the bowl and stand are visually equal in size. The heavily veined surface of the metallic cup looks anatomical and unsavory, exposing the "body" under the "skin."

As a further variation, a few stands were modeled after couch arms, as in *Untitled Mortar Bowl with Stand*, 1983 [36]. Termed "furniture fenestration" by Saxe and meant to present an eighteenth-century "folly conceit" in a late twentieth-century idiom, these works refer to an overstuffed couch with a food bowl (suitable for popcorn) precariously balanced on the arm.

Continuing his penchant for expressive surfaces, Saxe made *Untitled Mortar Bowl with Stand (Platinum Blue Mist)*, 1987 [37], with a stoneware base. *Untitled Mortar Bowl with Stand*, 1987 [38], has a stand that is bifurcated, fanning out from an implied center under the golden bowl. The implication of two halves joining under the container gives the piece a dynamic presence. In *Untitled Mortar Bowl with Stand*, 1983 [39], the bowl sits securely on a disk that forms the contact point between rough raku and smooth porcelain. The visual weight of the raku would overshadow the subtly glazed cup if it were not for the aggressively jagged rim.

In 1981 Saxe turned to the exploration of torso-shaped jars. Playing on the fact that vessels have long been described in terms of the human figure—neck, shoulder, body, foot—he extended these implicit anthropomorphic qualities to create this

[35]

Untitled Mortar Bowl with Stand (Boudin Noir)
1987

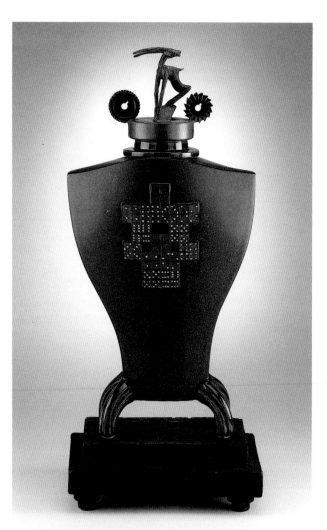
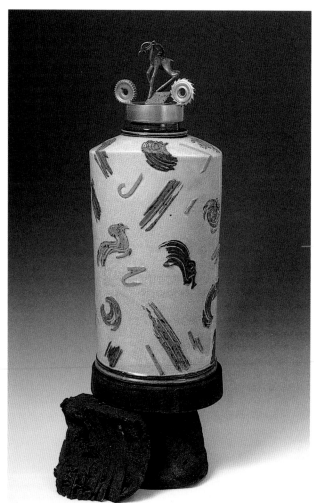

series of complex works. An early torso jar is the *Untitled Covered Jar on Stand*, 1980–82 [40]. Saxe derived the basic torso shape from his early oil lamps (see [16–17]), turning them upside down. A miniature version of the vessel was placed on the lid to serve as a finial, creating a visual homology. In 1982 a raku plinth was added in order to increase the presentation qualities of the work. The utilitarian form functions ambiguously, luring the viewer into speculation about the mixed messages of form and utility. This desire to tease and baffle makes Saxe's work subversive.

Another torso jar is the *Untitled Covered Jar on Stand with Antelope Finial (Lucas)*, 1983 [41]. A blue-glazed torso form on a stepped raku base is topped with two blue gears and an antelope peering over its shoulder. Most intriguingly, on the front and back are arrangements of slightly reduced dominoes in patterns that refer to both the quadrilles of Lucas and circuit boards.[24] The "front" and "back" are differentiated by the two versions of this decoration.[25]

Saxe also began constructing a series of straight-sided, lidded jars. *Untitled Covered Jar on Stand with Antelope Finial*, 1982 [42], and *Untitled Covered Jar on Stand with Antelope Finial*, 1983 [43], both balance precariously on asymmetrical bases. Decorated in "juiced up"[26] colors, the pieces are embellished with shapes reminiscent of Roy Lichtenstein's painted brushstroke depictions (FIG. 7) and the folded paper imagery of Richard Tuttle. This combination brings the larger art world and the decorative arts conventions of these ceremonial trophies into parity. A similar work from the same period is the *Untitled Covered Jar on Stand with Antelope Finial*, 1982 [44], which sits on a mold-made raku base.

This latter piece shows that yet another shape had entered Saxe's repertoire of forms: the Buddhist bell. Unlike the torso jars, which emphatically require a frontal presentation, the bell forms exist in the round, with the finial determining the front of the piece. The frontality of later works was decided by their decoration. *Untitled Covered Jar on Stand with Antelope Finial*, 1985 [45], is an example of this. The brushstrokes on each side, rendered in three dimensions and glazed with gold lusters, are featured as central reliefs. Equally elegant and evocative is the *Untitled Covered Jar on*

FIGURE 7

Roy Lichtenstein
(United States, b. 1923)
Little Big Painting
1965
Oil and synthetic polymer
paint on canvas
68 x 80 in.
(172.7 x 203.2 cm)
Collection of the Whitney
Museum of American Art, New
York, purchase, with funds from
the Friends of the Whitney
Museum of American Art, 66.2

[41]

**Untitled Covered Jar on Stand
with Antelope Finial (Lucas)**
1983

[43]

**Untitled Covered Jar on Stand
with Antelope Finial**
1983

Stand with Antelope Finial (Sacred Heart), 1984 [46]. Here Saxe returned to the torso shape, which is cleverly complemented by the heart-shaped medallions placed on the front and back. The function of such decoration is to add prestige borrowed from fine arts conventions to decorative arts objects. This strategy is similar to that seen in the court porcelains of eighteenth- and nineteenth-century Europe.

Sèvres

In the fall of 1983 Saxe was awarded an artist's fellowship and six-month residency at L'Atelier Experimental de Recherche et de Création de la Manufacture Nationale de Sèvres in France. This invitation marked the beginning of a new program, overseen by the Ministry of Culture, for visiting artists at Sèvres. His work appealed to the French because it united the utilitarian and decorative aspects of clay.[27]

The Manufacture Nationale de Sèvres embodies the long history of porcelain as a precious commodity. Valued for its hardness and white body, suitable for brilliant glazes and painted decoration, porcelain was first made in China during the Tang dynasty (618–906).[28] The Chinese exported their wares to both Middle Eastern and Western markets. In Europe these rare, utilitarian objects were prized by the aristocracy and used in their ritualized drinking of tea and chocolate.[29] The Chinese monopoly continued until European factories learned how to manufacture porcelain.[30]

Through the chance blessing of a kaolin deposit and enterprise coerced by Augustus the Strong of Saxony from alchemist Johann Friedrich Böttger, the costly and technically challenging search for a true European porcelain paste paid off in 1709. With this accomplished and with the need to finance Augustus's expensive habits, the Meissen factory was established in 1710 to produce "white gold." By 1727 Böttger had successfully developed a porcelain body appropriate for shaping, a vocabulary of forms similar to the cups, plates, and bowls from China, a palette of sixty enamel colors,[31] and a reliable gilding technique.

The pieces first produced at Meissen were utilitarian and small. Basing its wares on the reworked Chinese forms and German metalwork shapes, Meissen

became known for its finely painted decorations. The factory also made delicately modeled polychrome figurines reminiscent of German carved ivory and wood. Meissen's porcelain monopoly slipped as other factories in Europe discovered the magic of hard-paste porcelain. Among them were the English firms of Chelsea, Bow, Derby, and Worcester as well as Sèvres in France.[32]

Sèvres, founded initially in 1753 at Vincennes outside Paris, moved down the Seine to its namesake location in 1756, where it came under direct royal control. Due to the factory's backing from Louis xv and other aristocrats, the porcelain wares it produced carried considerable prestige. Established to create "porcelain in the manner of Saxony,"[33] Sèvres was a commercial enterprise organized for the design and manufacture of decorative and utilitarian porcelain objects.

In the beginning only soft-paste porcelain was made at Sèvres. Its translucent surface was visually softer than that found on Chinese or Meissen hard-paste porcelains. This characteristic, coupled with a penchant for chipping and scratching, imbued Sèvres porcelain with an aura of fragility that increased its precious associations.[34] Adding further to this, it became customary for ambitious courtiers who desired access to Louis xv to make an appropriate purchase from his porcelain factory. This act of support for the king's business venture, coupled with partaking of a material prized by the royalty, meant acquiring additional reflected glory. Owning these "noble treasures"[35] enhanced one's social status.

In time Sèvres established a range of standard functional forms. These stock shapes were designed in several sizes and conceived of as working in concert with other factory designed shapes. When arranged in groups of two to five, these sets formed garnitures. Sometimes assembled into groups by porcelain dealers after the works left the factory,[36] these garnitures were sold to discerning patrons.

In addition to the vases sold singly or in garnitures, Sèvres also produced figurative table sculptures based on pictures and engravings. They featured subjects related to rare pleasures, trappings of power, romantic and indulgent games, popular entertainment, and religious imagery.[37] These evocative fantasies did not

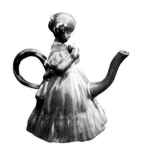

FIGURE 8

Untitled Teapot (Little Shepherdess)
1973
Porcelain
7½ x 6 x 7 in.
(19.1 x 15.2 x 17.8 cm)
Private collection

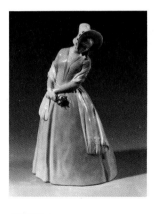

FIGURE 9

Deutsche Werkstätten,
Munich
Spring
1912
Whiteware
12 x 6⅞ x 6⅜ in.
(30.5 x 17.5 x 16.2 cm)
The Newark Museum

reflect the stern realities of everyday life but instead related to the myths and notions of honor of the rich and educated.

There were many uses for porcelain vessels and sculptures in the eighteenth century. Seen as proper decorative appointments for palatial interiors, they were placed on mantels and tabletops when not in use as tablewares and flower holders during meals. Set to advantage in front of mirrored chimney pieces and on pier tables, their well-decorated backs could also be appreciated. The bright ground colors invented by Sèvres as the factory developed were the most vivid available in the eighteenth century.[38]

The Sèvres invitation appealed to Saxe for a number of reasons. First, there was the opportunity to work with the hallmark soft-paste porcelain.[39] Second, he wanted to observe historical techniques firsthand and possibly employ some of the models from the eighteenth century. In addition, he wanted to study the handles and spouts of the utilitarian wares and to work with the ormolu-mount[40] foundry.

Toward the end of his stay Saxe did gain access to the soft-paste porcelain, but there was not enough time to create any work with it. Regarding mold making, although Saxe was familiar with the technique, he found the French rationale for modeling forms in plaster (a material not favored by American studio potters) a revelation. The procedure at Sèvres was based on making models of models instead of modeling directly from nature. While typical of the eighteenth century, this was abhorrent to the twentieth-century sensibility. After observing the work at Sèvres, however, Saxe came to appreciate the technical advantages of this method. The end result was less intricate, easier to rid of process marks, and less apt to break in firing.

Two other aspects of Sèvres production methods were significant for Saxe. Due to the nature of the Sèvres hard-paste porcelain, thrown forms were trimmed substantially to achieve desired thinness. While acceptable in a traditional factory, this violated the accepted tenets of clay-working craftsmanship that Saxe had absorbed as a young man. He also was impressed with the extensive use of gilding. Befitting a royal factory of luxury wares, substantial amounts of gold were used to decorate

Sèvres pieces. Saxe had utilized gold before working at Sèvres, but after the visit he
increased his employment of gold lusters to create aggressively opulent works.

He also benefited from living in the nineteenth-century environment of Paris,
after a lifetime of Los Angeles modernist and pastiche designs. This exposure honed
his appreciation of visually layered artwork and influenced his output in an indirect
manner. In 1987 he returned to Sèvres for a second fellowship at the factory.

The Sèvres experience was most important to Saxe for the validation it
awarded his work, not because of the molds or the gilding or the soft-paste porce-
lain. His creations had come out of isolation in a sense, not through any in-depth
knowledge of European (or Chinese) ceramic traditions. The Sèvres visit proved to
him that his guessing had been correct, that his presentation strategies and melding
of influences had historical precedents.

There are, of course, differences in approach between Saxe and Sèvres. Saxe,
for example, uses porcelain's white surface to explore glaze and luster effects,
not as a background for painting pictures. (His approach is, in fact, more oriental
than it is eighteenth-century European.) His choice of a porcelain body, however,
communicates the preciousness, status, and wealth traditionally associated with the
material. Both Sèvres and Saxe create display pieces and manipulate the effects that
presentation rituals have on how such objects are valued.

Also like Sèvres, Saxe makes figures and vessels as "toys for the imagination to
savour."[41] In 1963 he had begun collecting commercial hobby molds and figurines
for eventual use in his work. Many small artware producers and suppliers of green-
ware to the hobby trade were moving or going out of business as development
pressures in Laguna Beach and Newport Beach, California, changed these previously
agricultural and backwater light manufacturing districts into bedroom communities.
He eventually gave many of these molds to students and friends but maintained
a small collection for himself. He based his *Untitled Teapot (Little Shepherdess)*, 1973
(FIG. 8), on one of these molds. Reminiscent of such traditional European figurines
as the Deutsche Werkstätten's *Spring,* 1912 (FIG. 9), it is in the form of a demure

[47] *Page 40*

Sacred and Profane (Garniture)
1973

[48] *Page 41*

Untitled Covered Vessel (Ting)
1973

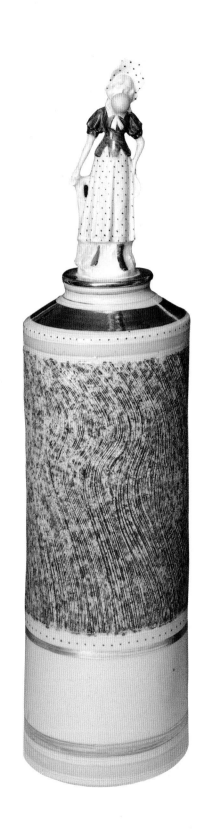

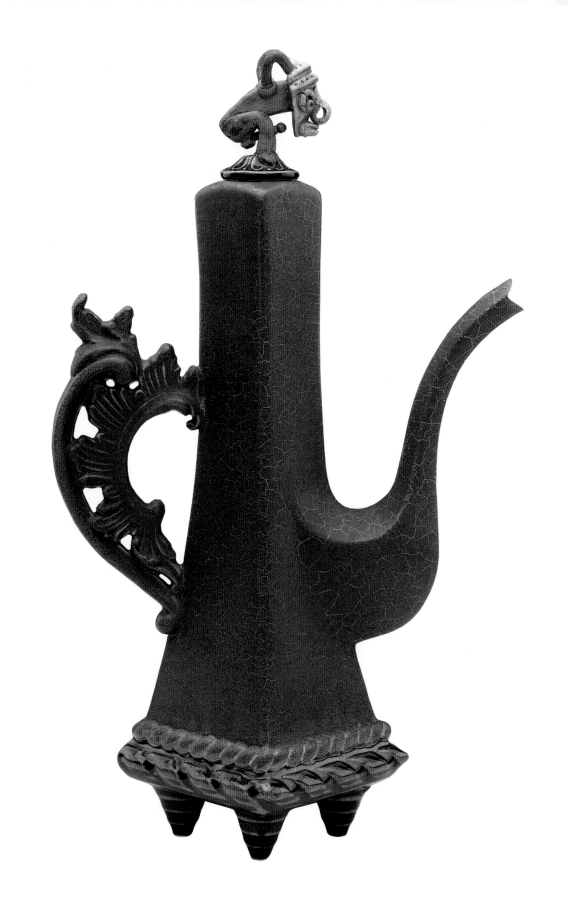

girl in a full skirt. As a "goof," however, the handle comes out of her back and the spout projects from her front. This blatant sexual innuendo is neatly balanced by the technically difficult copper-red glaze.

Another important piece of figurative work is *Sacred and Profane (Garniture)*, 1973 [47]. This two-part set features a linked pair of contrastingly rendered female figures (taken from hobby molds) standing atop column-shaped, slab-built, slip-decorated pedestals. One maiden, "Sacred," dressed in lavender, is blowing a large chewing gum bubble. Her companion, "Profane," glazed in red and black, has horns protruding from her head and poses saucily. Although rendered in vernacular imagery, *Sacred and Profane* relates to and updates the allegorical, porcelain tabletop figurines produced at Sèvres and Meissen during the eighteenth century.

In *Untitled Covered Vessel (Ting)*, 1973 [48], Saxe extrapolated from a fifth-century B.C. Chinese *ting* form (FIG. 10) used for ritual food preparation. The celadon vessel is topped with slip-cast high-heeled shoes (seemingly just slipped off) and a precariously balanced ball. This combination of Western footwear and Chinese metalware recalls Sèvres copying Meissen copying the Chinese.

At the Huntington, Saxe had seen the quirkiness of Sèvres forms. If vases could be gun towers, then why not make a teapot out of the Eiffel Tower? *La Tour Akan*, 1984 [49], is an example of teapot ingenuity and the interplay of forms and cultures. The body represents a satire of touristy Parisian souvenirs. The small finial figure was inspired by the exotic and often erotic Akan gold weights from Ghana (FIG. 11). (While the Asante and Akan peoples were mostly included in the former British colony known as the Gold Coast, indigenous art from Ghana is popular in France.) The piece was defined as it was assembled. The body, spout, and fretwork around the base were slip cast; the handle was made as a separate press mold. The lid was assembled from a slip casting and a pressed part; each finial figure was individually modeled. The feet were press molded.

FIGURE 10

Ting
China, first quarter fifth century
B.C.
Bronze
13½ x 15½ (diam.) in.
(34.3 x 39.4 cm)
Los Angeles County Museum of
Art, gift of Mr. and Mrs. Eric
Lidow, M.74.103

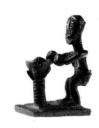

FIGURE 11

Akan Gold Weight
Ghana, twentieth century
Brass
1¼ x 1⅛ x ⅝ in.
(3.2 x 2.8 x 1.6 cm)
Fowler Museum of Cultural
History, University of California,
Los Angeles, gift of the
Wellcome Trust

[49]

La Tour Akan
1984

43

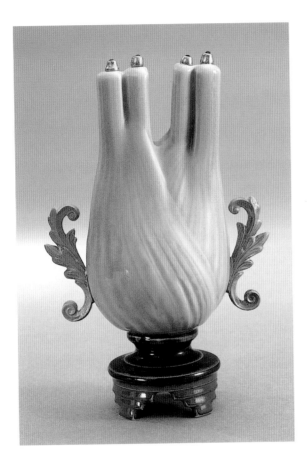
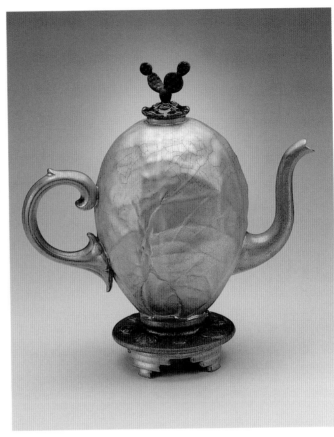

Saxe also skewered the preciousness inherent in the European ceramic tradition of making vessels in the form of vegetables. Almost all historical uses of natural forms like these in art and design depended on extensive interpretation and abstraction of the observed form. For example, eighteenth-century French artists followed an elaborate sequence of study and development before incorporating something from nature in a finished work: first carefully observing and drawing from nature, then redrawing idealized images synthesized from these studies, next abstracting and stylizing the form for adaptation to a model, then further developing the model, and finally committing it to a mold. Saxe worked directly from the actual vegetables. In two ewers [50–51] the richly glazed eggplant bodies sit jauntily on their bases. Made functional by their rococo handles and geometric spouts, the pieces are topped by acanthus leaves and finials (one a stem, the other a snail). The works seem capable of actually lurching across the table. A large squash form was used for the body of *Untitled Teapot (Pattypan Squash)*, 1982 [52]. *Untitled Ewer (Bittermelon)*, 1982 [53], is made utilitarian through the addition of a squared handle and spout. One of Saxe's most successful works is *Untitled Oil Lamp (Fenouil)*, 1985 [54], an eight-inch-tall, celadon oil lamp in the shape of *fenouil* (fennel). With wicks placed at the top of all four shoots, the form, adorned with gold-lustered handles, sits on a step-legged plinth. The juxtaposition of content inherent in the luted-together forms results in a hapless vegetable dressed up and ready for dignified self-ridicule.

A more glamorous, golden variation of this is the *Untitled Ewer (Chou)*, 1989 [55]. The *chou* (cabbage) is topped with a cactus plant and sits on a base decorated with seashell shapes. It combines all of Saxe's trademarks: a functional armature with whimsical form contrasts and a beautiful glazed surface spiced with a poke at luxury taste. *Untitled Ewer (Chou)*, 1991 [56], adds blue rhinestones to the mix. *Untitled Ewer*, 1991 [57], and *Untitled Mystery Ewer*, 1991 [58], are in a similar vein. In the latter vessel a ceramic conundrum is posed: how would it actually work? The attachments take on the feeling of fetishes, implying a history for either the piece or its owner.

[54]

Untitled Oil Lamp (Fenouil)
1985

[55]

Untitled Ewer (Chou)
1989

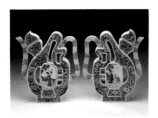

FIGURE 12

Pair of Chinese Character Winepots

China, nineteenth century

Porcelain and enamels

Each: 10½ x 9 x 3 in.

(26.7 x 22.9 x 7.6 cm)

Private collection

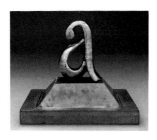

FIGURE 13

Jim Melchert

(United States, b. 1930)

Precious a

1970

Earthenware and lusters

6 x 8½ x 6 in.

(15.2 x 21.6 x 15.2 cm)

Private collection, Boston

[61]

Untitled Ewer (Franklin Gothic Italic Ampersand)

1989

[62]

Untitled Ewer (French Curve)

1989

Saxe also reinterpreted conventional Asian winepots, like those in the shape of Chinese characters (FIG. 12). Made since the seventeenth century, these vernacular forms were often shaped to resemble the character *fu*, representative of good fortune and happiness. Executed in white porcelain and painted with enamels, these table-sized display pieces were revived in the nineteenth century as tourist wares. They visually meld utilitarian form, calligraphy, and philosophical content.

Extrapolating from this theme, Saxe created a series of ampersand ewers. Also table sized, these pieces capture the same multiple meanings as their Chinese antecedents. He added an enlivening touch of humor missing from the character teapots by topping off his graphically correct symbols with incongruous cactus finials. Such objects as *Untitled Ewer (Clearface Gothic Extra Bold Ampersand)*, 1989 [59], bring to mind Jim Melchert's "a" sculpture (FIG. 13). In *Untitled Ewer (Fatface Bold Ampersand)*, 1989 [60], the mold-made body is covered in an exquisitely variegated gold and platinum *craquelure* glaze. The handle is a nineteenth-century Sèvres model; the finial is an updated rendering of the cactus placed on a roundel of acanthus leaves. *Untitled Ewer (Franklin Gothic Italic Ampersand,* 1989 [61], leans forward, making the most of its italic stance. All of these amusing wares present a rich combination of contrasting cultural references.

The French curve series—based on a drafting tool—was also derived from the character teapots. In *Untitled Ewer (French Curve)*, 1989 [62], the same handle as seen on [60] counterbalances the inherently complicated nature of the irregular form. Again the finial is a cactus. This interweaving of theme and variation with related forms indicates the constant playfulness that Saxe uses in his work.

That playfulness can have a darker undertone, however, as seen in the snail jars. An early example is the *Untitled Stoppered Jar*, 1985 [63]. In this work the snail is deployed like living bait, a lure for the unwary. The sturdy stoneware base and dark green bracket, which is similar to the scroll shapes seen in some of the oil lamps [21–22], are combined in an unsettling way, appearing to form some kind of giant escargot. Two years later Saxe created *Untitled Covered Jar on Stand*, 1987 [64].

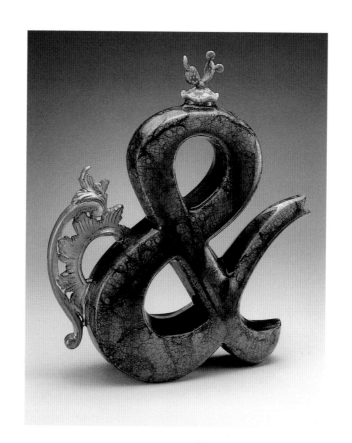

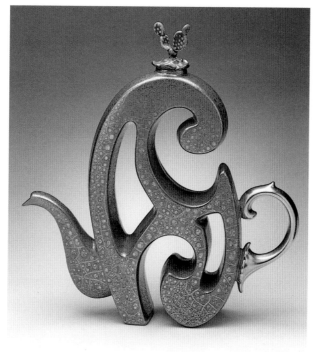

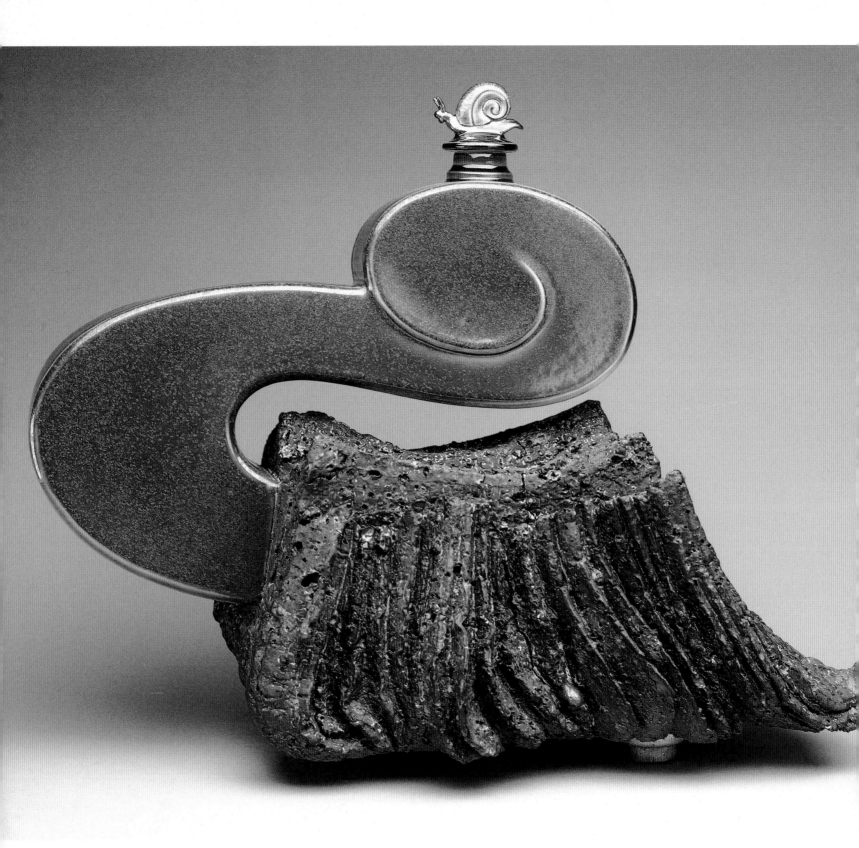

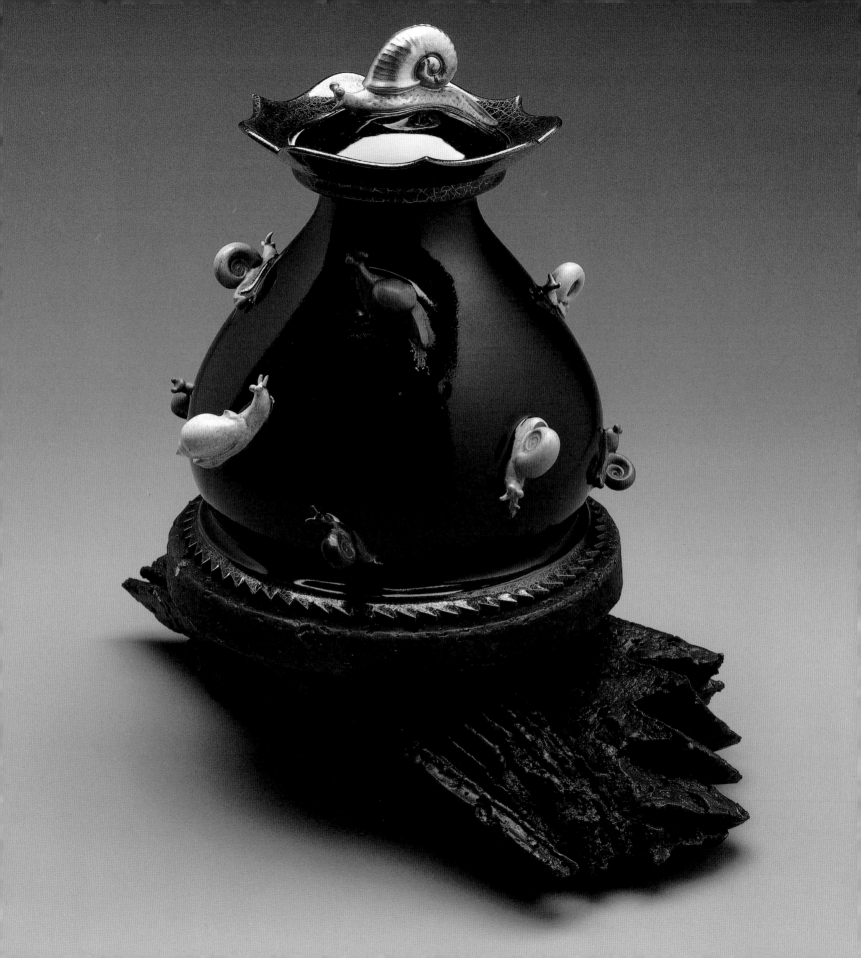

The main body of the piece is a thrown, circular, lidded jar dotted with brightly colored lifelike snails. The assemblage sits on a jagged raku base. The rendering of the snails is correct down to the trails of oozing slime they leave on the glaze surface.

Applied surface decoration had become more of a concern for Saxe after his Sèvres experience. He became fascinated with the ornamental potential of ordinary buttons. Used as both a functional closing device for clothing and for mere embellishment, buttons are sculptural by nature and often made of inexpensive materials that imitate exotic ones. Saxe, long a devotee of junk stores and flea markets, applied buttons to his works as if they were globs of articulated gold, turning trashy trinkets into art. The everyday was transformed into high status (paralleling pop art's penchant for celebrating the banal).

When first working with buttons, Saxe used just one design per vessel. An early example is the *Untitled Covered Jar*, 1985 [65], which has applied, golden, three-dimensional buttons as decorative projections on the bright blue torso. They activate the surface with light and glitter and add to the shieldlike appearance of the body, with its gold fleur-de-lis. The defense provided by the shield is threatened by the bomb used as a finial, however.

A further development is seen in the *Untitled Covered Jar on Stand with Antelope Finial (Esperluète)*, 1987 (FIG. 20; see page 132). Here the buttons—press molded from impressions taken from antique French fasteners—surrounding the *esperluète* (ampersand) are varied in their style and shape. This work is about the obsessive gathering of many little bits of "worthless bric-a-brac."[42] Transforming functional items into objects of display and status, Saxe's button pieces are essays on the commodification of all the arts.

The surface of *Untitled Covered Jar on Stand with Antelope Finial (Garth Vader)*, 1986 [66], is activated by an array of press-molded buttons, coins, medals, and souvenir pieces from the small flea markets of Paris. Using the title for added humor, Saxe combined a reference to the evil character Darth Vader, from the movie *Star Wars*, with the name of Garth Clark, Saxe's friend and dealer.

Untitled Covered Jar on Stand with Antelope Finial (Prosperity), 1987 [67], was conceptualized as an homage to folkloric Chinese petitions to the spiritual world for good luck and wealth. A mélange of doodads and gewgaws—a literal shower of blessings—surrounds the character for prosperity (the same as in FIG. 12).

Other unique forms also show Saxe's interest in surface decoration. As mentioned earlier, the vermiculé patterning on Sèvres porcelain at the Huntington inspired Saxe. In *Untitled Covered Jar on Stand with Antelope Finial*, 1982 [68], he combined wormlike squiggles with random jottings influenced by the work of Ed Ruscha (FIG. 14). A similar treatment is seen in *Untitled Jar (Double Spiral)*, 1986 (FIG. 15), where a cobra guards the golden emblems. The scribbles in turn led to the stonelike applications seen in *Untitled Covered Jar on Stand (Molly)*, 1983 [69], which was inspired by the carburetor of a motorcycle. The work *Untitled Covered Jar on Stand with Antelope Finial (10,000 Pieces)*, 1986 [70], also features a striated addition to the surface: slip that has been applied in lines and dots. The character translates as an "undertaking," referring to the Buddhist path to enlightenment of ten thousand steps (or prayers or virtuous acts). All of the strategies used by Saxe enliven the surface and tease the imagination.

In 1989 Saxe began a series of works based on inedible gourds, one of the primal utilitarian vessel forms. This was a natural outgrowth of the vegetable and organic explorations begun earlier. After selecting and drying the gourds, he took mold impressions directly from them.

Saxe made his first gourd pieces as single vessels. *Untitled Covered Jar*, 1989 [71], has a curvaceous shape, which he complemented by "putting on the make-up"[43] of a lustrous brown glaze punctuated with a gold craquelure. Set on a golden tripod base, the jar is made anthropomorphic through the addition of elongated ears and a quizzical, pointed lid topped with a clay squiggle. The body is decorated with gem settings holding rubies. As with the early oil lamps, the form seems to sway on its tripod feet.[44] In *Shirley's Friend*, 1989 [72], cubic zirconia "diamonds" were employed to set off the rich green surface of the gourd form. The gold-lustered,

FIGURE 15

Untitled Jar (Double Spiral)
1986
Porcelain, raku, and lusters
20½ x 10 x 6 in.
(52.1 x 25.4 x 15.2 cm)
Private collection, Suffolk, England

[69] *Page 52*

Untitled Covered Jar on Stand (Molly)
1983

[70] *Page 52*

Untitled Covered Jar on Stand with Antelope Finial (10,000 Pieces)
1986

[71] *Page 53*

Untitled Covered Jar
1989

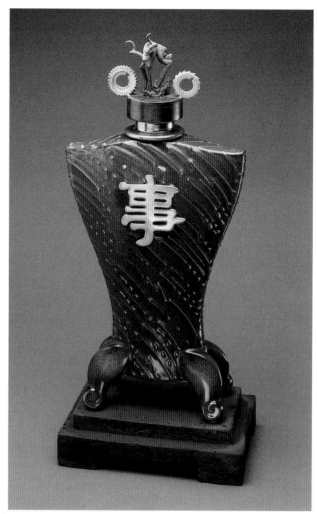

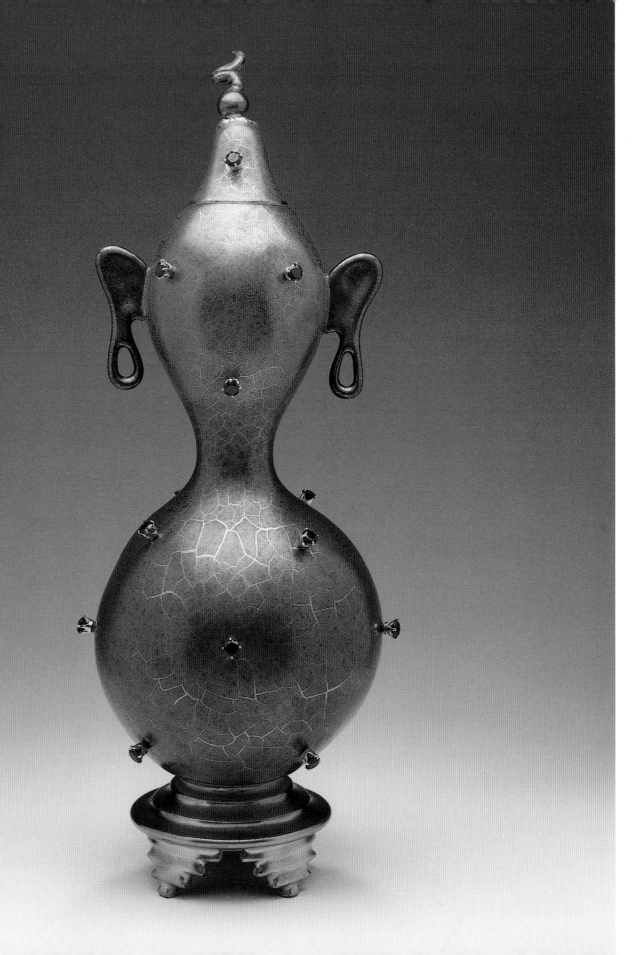

FIGURE 16

a & b

1987

Porcelain and lusters

a: 11⅝ x 5¼ x 5¼ in.

(29.5 x 13.3 x 13.3 cm)

&: 19 x 7½ x 9 in.

(48.3 x 19.1 x 22.9 cm)

b: 12 x 4¾ x 4¾ in.

(30.5 x 12.1 x 12.1 cm)

Dorothy and George Saxe, San Francisco (promised gift to the Toledo Museum of Art)

FIGURE 17

Virgule

1990

Porcelain, lusters, wood, and silk

24 x 37 x 8⅞ in.

(61.0 x 94.0 x 22.5 cm)

Collection of Shigaraki Ceramic Cultural Park, Japan

[74]

Threshold of Violence Generating Stress

1990

quixotic handles create an angular contrast with the overdressed, curvy whole. Saxe uses imitation jewels to reinforce the implied intrinsic value of these works. Functioning as status objects, tweaking the noses of his public, they would lose their parodic nature if made of truly precious materials.

Explosive Decompression, 1990 [73], is decorated with a gray luster crackle glaze also studded with applied cubic zirconia. A wavy skirt dances between the bulk of the work and the solid base. Gold arabesque handles balance the finial, which is a quartz crystal in the shape of a mushroom cloud.

Threshold of Violence Generating Stress, 1990 [74], is a squat gourd form drenched in a silvery luster coating. The glaze, which still seems to be dripping, partially obscures the hatch-mark pattern carved into the surface. Standing on four legs, the piece has curly, craquelure handles and is topped with a sharp-edged chunk of glass. As so often occurs with Saxe's work, the implied function is rendered useless by the off-putting finial.

In *Bwayne Cwazie*, 1990 [75], Saxe returned to a blend of whimsy and popular culture. Here rich gold lusters were applied over sugary microcrystalline glazes on a gourd surmounted by Mickey Mouse ears with a diamond stud placed in the proper left ear. The lid is fashioned after a twisted plant tendril and resolves itself into an eighteenth-century drapery pull. The elegant work is saved from pomposity by a fillip of humor. Similar gourd shapes are seen in *Dents de la mer*, 1990 [76], and *Dents de la mer II*, 1991 [77]

As a further development of the gourd form, Saxe wittily created garnitures out of assembled groupings. The inspiration for this was the polychromatic Kutani gourd garnitures of seventeenth-century Japan. In *a & b*, 1987 (FIG. 16), three orange-speckled vessels are topped with typographical finials. Spelling out "a & b," this piece is an early movement toward the incorporation of letters and words into Saxe's compositions.

Virgule, 1990 (FIG. 17), is a garniture with two examples of wordplay. The first involves the OY-YO anagram; the second features the golden cord that languorously

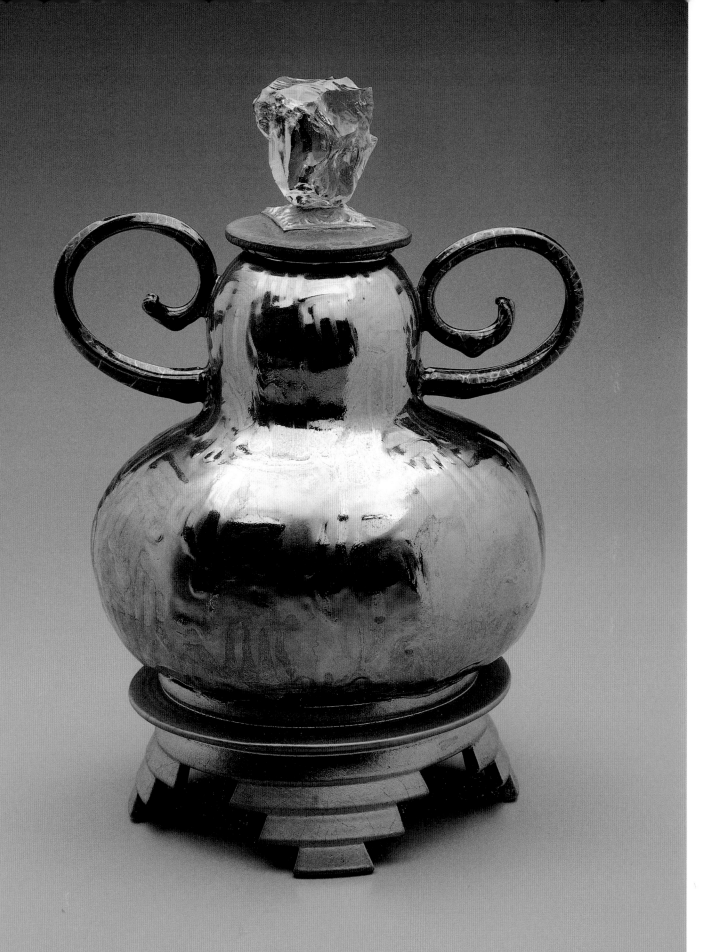

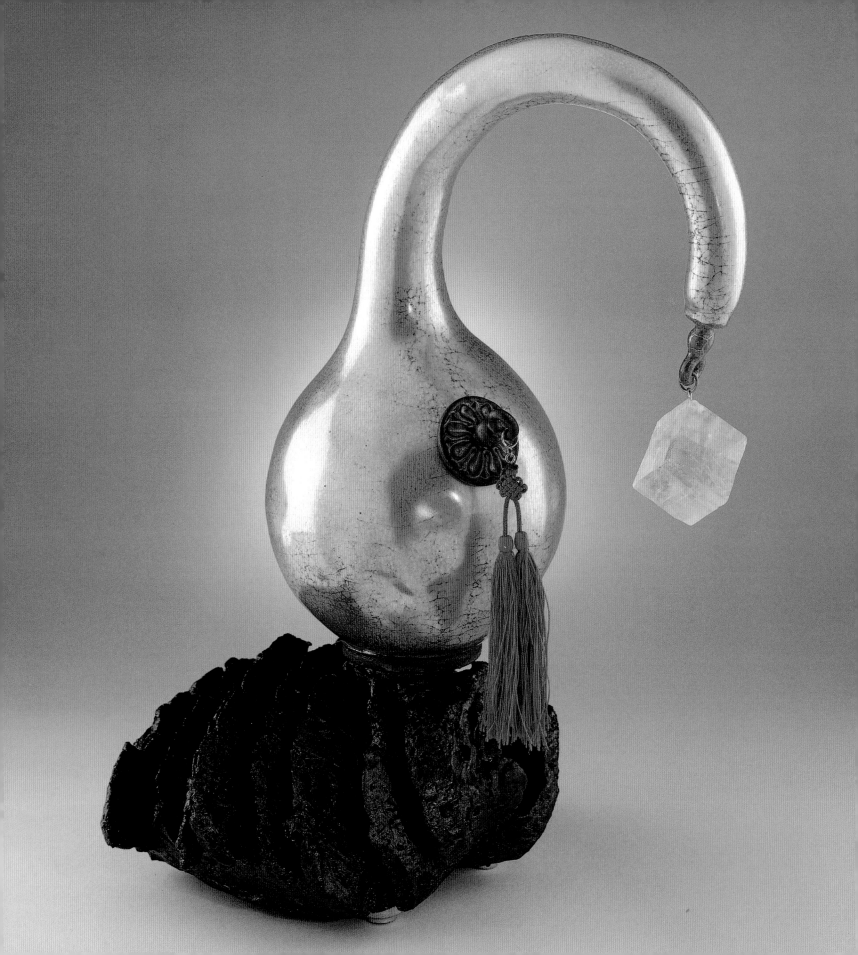

binds the two vessels together, a reference to the title. The cord functions as a three-dimensional slash mark (O/Y-Y/O). In *Vomiturition*, 1990 [78], Saxe returned to his button strategy but combined it with language. The slang word *YO* is transmuted into an elegant decorative motif, a marriage of the common and the esoteric.

Like *Virgule*, *ELVIS/LIVES (Garniture)*, 1990 [79], has an additional compositional element: a console shelf. It corresponds with the interior architectural settings where historic European garnitures were displayed but dictates a contemporary mode of viewing the piece by forcing specific conditions, including visually isolating it on a wall away from the influence of furniture and connections to decorative function. The five-gourd garniture is tied together with an anagram that reads ELVIS on one side and LIVES on the other. This interest in wordplay and in controlling the context in which the works are displayed discourages the audience interaction once encouraged.

The next group of gourds is Saxe's most ambitious attempt at paralleling historical Sèvres vases. *Entre nous*, 1990 [80], is a restrained form with a green woven swag, checkered cylindrical base, and flounce. Covered in a brown crackle glaze, the piece is elegant yet mischievous. In *Seasonal Affective Disorder*, 1991 [81], a gourd with a curved neck is balanced on top of a raku base and decorated with an over-scale Chinese fluorite crystal. Again opulence and whimsical form are expertly joined. In *Sur le bout de la langue* (On the tip of the tongue), 1991 [82], a golden gourd is topped with a tendril. It is further embellished with a fishing lure, eighteenth-century tassel, and other personal fetishes. Again the rich cross-references and deft handling of multiple parts trumpet the unique Saxe style.

Saxe also worked on a small series of long, straight-necked gourds. In *Phytogenic Object of Affection*, 1992 [83], the phallic shape is emphasized through the addition of two dangling dried pears.

Cacaboudin, 1992 [84], and *Cacaesthesia*, 1992 [85], are Saxe at his most outré. The works, made from the same gourd mold, refer through their titles to the

[81]

Seasonal Affective Disorder
1991

57

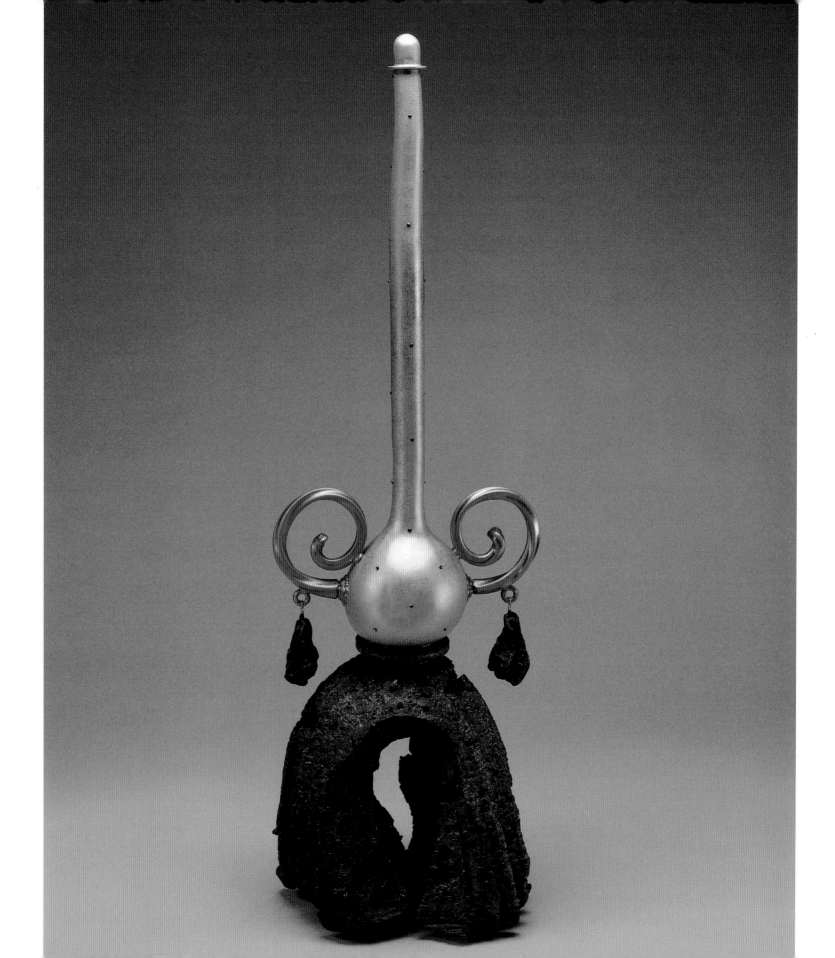

childish term for excrement. *Cacaboudin* is also related to *Boudin Noir* [35]. A greasy and visceral surface suggestive of an intestinal casing is rendered in black porcelain with gold veining. *Cacaesthesia*, not only reflective of waste, conjures up sexual imagery as well. It seems to have what the definition of the word *esthesia* promises: a capacity for sensation and feeling. These latest pieces mix all of Saxe's interests, from funk to French to fetish.

Adrian Saxe is a unique artist whose work with the functional vessel has invigorated the decorative arts heritage of revering utilitarian forms. His elevation of claywares into essays on presentation place his pieces both outside the range of usual late-twentieth-century ceramics and, ironically, within the court traditions of previous eras in Europe and Asia. In making evocative and pungent works freely laced with diverse references, Saxe is clearly a contemporary artist whose medium happens to be the vessel. He stands alone in his art.

[83]

Phytogenic Object of Affection
1992

[85] *Page 60*

Cacaesthesia
1992

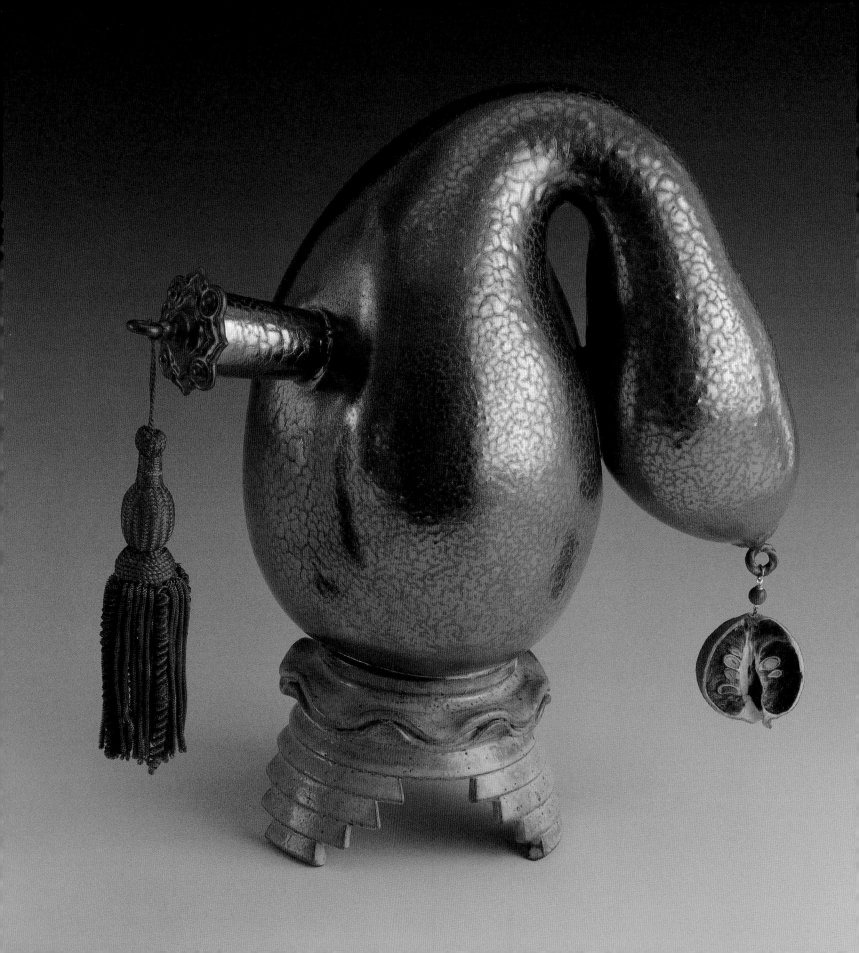

NOTES

1

Peter Schjeldahl, "The Smart Pot: Adrian Saxe and Post-Everything Ceramics," in *Adrian Saxe*, ed. Craig Allen Subler (Kansas City: University of Missouri-Kansas City Gallery of Art, 1987), 13.

2

Immanuel Kant wrote in 1790: "Art also differs from handicraft; the first is called 'free,' the other may be called 'mercenary.'" See Immanuel Kant, *Critique of Judgment*, trans. J. H. Bernard (New York: Hafner Press, 1951), 146.

3

See John Berger, *Ways of Seeing* (London: British Broadcasting Corporation and Penguin Books, 1972). Written to accompany a television series, this book influenced a generation of artists to the relative meanings of function. Within Berger's matrix, Hans Holbein's court portraits, while not functional in a utilitarian way, can be seen as statements of status and position that elevated the people portrayed in them.

4

Garth Clark, conversation with author, April 1992.

5

Rick Dillingham, conversation with author, March 1992.

6

For a complete discussion of the reverence for the humble brown pot see Martha Drexler Lynn, *Clay Today: Contemporary Ceramists and Their Work* (Los Angeles/San Francisco: Los Angeles County Museum of Art/Chronicle Books, 1990), 13–28.

7

This type of wheel originated at Ohio State during the late nineteenth century. Derived from an English prototype, it was sturdy, professional, and easy to make.

8

Jerry Rothman, conversation with author, November 1991.

9

Adrian Saxe, conversation with author, April 1992.

10

Quoted from the label on the back of the game.

11

New ceramic techniques were often discovered by engineers who worked in industry. Because of the separate concerns of the engineering and artistic worlds, this information generally did not cross over into artistic applications.

12

Mold making was an industrial technique. Because it was a method of producing multiple works mechanically, the technique was anathema to the craftwork ethos of the period. Consequently, mold making was not taught at art schools like Chouinard. The concept did interest a number of students, however, and Saxe's classmate David Dickson experimented with making molded forms. This, coupled with technical information from potter John Karrash, helped Saxe start making molds. Now mold making is part of all ceramics curricula.

13

Saxe repeatedly refers to such postures and the effect they have on how viewers respond to his works.

14

See Glenn C. Nelson, *Ceramics: A Potter's Handbook*, 3d ed. (New York: Holt, Rinehart and Winston, 1971), 7–12.

15

For illustrations of porcelain works at the Huntington see Robert R. Wark, *French Decorative Art in the Huntington Collection* (San Marino, California: Henry E. Huntington Library and Art Gallery, 1961).

16

Jean Baudrillard, *Selected Writings*, ed. Mark Poster (Palo Alto, California: Stanford University Press, 1988), 166–84.

17

Sèvres hard-paste porcelain was developed later and came to replace soft-paste porcelain. The inherent beauty of soft paste is preferred by many, however.

18

For an extended discussion of the symbolism of antelopes see Garth Clark, "Adrian Saxe: An Interview," *American Ceramics* 1, no. 4 (Fall 1982): 22–29.

19

Cactus as a decorative device has interested Saxe for a long time. Used by fellow Chouinard student Juanita Jimenez Mizuno, it was adapted by Saxe as a finial element. Saxe's girlfriend (and later wife) was also influential: she oversaw the cultivation of the desert section of the Huntington Botanical Gardens during the early 1970s.

20

Saxe uses this term to describe a playful treatment of a given topic. In the oil lamps he translated a folkloric symbol, Aladdin's lamp, into an experiment in space activation and examination of the role of personal objects.

21

The wick mechanism was difficult for owners to maintain. Although Saxe designed a new burner for his pieces, the necessity of tending the lamps discouraged collectors from using them.

22

Saxe was inspired by the use of gears in *Modern Times*, Charlie Chaplin's popular film of 1936. This theme was also seen in the work of Allan McCollum in the 1989 exhibition *A Forest of Signs: Art in the Crisis of Representation* at the Museum of Contemporary Art in Los Angeles.

23

This concept of participatory artwork can be found in a number of media, most notably in fiber art. Sheila Hicks, for example, has created works that can be assembled by their owners. See Martin Eidelberg, ed., *Design 1935–1965: What Modern Was* (Montreal: Le Musée des Arts Décoratifs de Montréal, 1991), 299.

24

Named by Edouard Lucas, a French nineteenth-century mathematician, quadrilles are "domino bones so arranged that four of the same spots can be placed next to each other in squares." See K. W. H. Leeflang, *Domino Games and Domino Puzzles*, trans. Irene Cumming Kleeberg (New York: St. Martin's Press, 1972), 37.

25

Some owners have reported that they did not realize the front and back sides of their pieces were different, even after having them in their possession for significant periods of time.

26

Adrian Saxe, conversation with author, April 1992.

27

Georges Jeanclos of Sèvres, along with a delegation of French ceramists, journalists, and educators, saw Saxe's work in the *Pacific Currents/Ceramics 1982* exhibition at the San Jose Museum of Art. Jeanclos and the others, seeking to invigorate and radically contemporize the creative activities at Sèvres, extended an invitation for Saxe to work in France. Betty Woodman and Viola Frey were to follow Saxe to Sèvres, representing the sculptural side of American clay.

28

Kaolin, the key ingredient necessary for the making of true, vitreous porcelain, is named after the hill in China (Kao-ling) where this mixture of fine white clay and kaolinite (hydrous aluminum silicate) was originally found.

29

Tin-glazed earthenwares, known from the fifteenth century, were an attempt to copy the true porcelains from China. Forms were coated in opaque tin glaze to provide a white surface for decoration. Two famous types were Italian majolica from Deruta and Dutch Delft.

30

In the fifteenth century porcelain was used for barter along the silk route. By the sixteenth century larger amounts of wares were being brought into Europe and offered for sale. Due to the difficulty of transport, Chinese porcelain was still highly valued. By the eighteenth century the Chinese had established export factories, which shipped large orders to the West. It was at this time that Chinese porcelains became less expensive than the court porcelains produced at Meissen and Sèvres.

31

Antoine d'Albis, conversation with author, May 1991.

32

There were also small noncompetitive factories in Italy owned by the Du Paquier family and the Vezzis. For more information see Hugo Morley-Fletcher, *Antique Porcelain in Color: Meissen* (New York: Doubleday & Company, 1971).

33

Tamara Préaud, *Sèvres Porcelain*, trans. James B. Davis (Washington, D.C.: Smithsonian Institution Traveling Exhibition Service, 1980), 16.

34

The soft-paste porcelain made at Sèvres combined a number of indigenous ingredients that imparted a unique character of visual softness and sheen and served as a fine base for painting and gilding. This body is no longer made; it is likely that the procedure for formulating the mixture has been lost. No contemporary production of the paste has the same character as the original.

35

Philip Rawson, *Ceramics* (Philadelphia: University of Pennsylvania Press, 1984), 64.

36

Rosalind Savill, *The Wallace Collection: Catalogue of Sèvres Porcelain*, vol. 1 (London: The Wallace Collection, 1988), 23.

37

Rawson, *Ceramics*, 200.

38

Ibid., 133.

39

The soft-paste porcelain at Sèvres is stored in a vault to protect it from unauthorized uses.

40

Ormolu is a gilt bronze that was often used for mounts for eighteenth-century furniture and Chinese porcelain. Powdered gold was combined with mercury and applied to the bronze, a process that created a highly toxic vapor. This led to the eventual abandonment of the technique.

41

Rawson, *Ceramics*, 204.

42

Amy Fine Collins, "Adrian Saxe at Garth Clark," *Art in America* 76, no. 3 (March 1988): 149.

43

Garth Clark, conversation with author, April 1992.

44

See Pamela Blume Leonard, "Decorative Art Is Better Than Not-Quite-Art," *American Ceramics* 10, no. 1 (Spring 1992): 12–13.

[11]

[48]

[39]

[45]

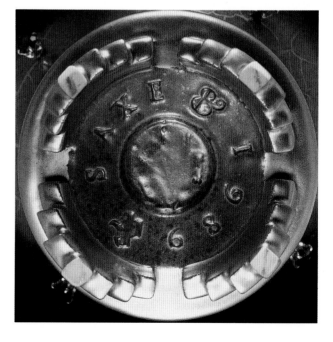

[71]

Checklist

NOTE: *This listing provides additional information on many of the works discussed in the essays. Much of this material was drawn from conversations with the artist. The checklist is organized according to the order in which works are mentioned in the Lynn essay. Page numbers and arrows below certain captions indicate the location of color illustrations.*

[1]

Pie-ku

1967
Raku
3 x 9¼ (diam.) in.
(7.6 x 23.5 cm)
Collection of George Wight

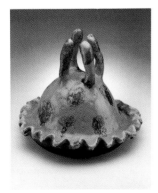

[2]

Cow Pie: Udderly Delicious

1968
Raku
7⅜ x 9½ (diam.) in.
(18.7 x 24.1 cm)
Private collection

During the 1960s Robert Arneson and other Bay Area ceramic artists turned from making pottery (highly expressionistic but still pottery) to crafting sculptural clay objects. While often taking the form of such banal items as beer bottles or toilets, these works included ironic or humorous twists. Most painters and sculptors found it difficult to understand or accept contemporary American ceramics other than as utilitarian wares. Fellow artists often sardonically asked Saxe: "What cha got cookin' in the oven?" A series of about twenty raku pies was his way of participating in what he called the "Yuk! Yuk! School of Ceramics."

In *Pie-ku* and *Cow Pie: Udderly Delicious* Saxe began to experiment with wordplay between the title of the work and the object presented. *Pie-ku*, for example, is a pun on the word *haiku*. An actual haiku that refers to a pie is incised in the crust: "Sakuranbo anata no tame ni pai ni iru" (I have put some cherries in a pie for you). These artworks relate through their medium to a type of clay body and process used by ceramists Carlton Ball, Warren Gilbertson, Jean

[3]

Hair Pie

1968

Raku

2½ x 9¼ (diam.) in.

(6.4 x 23.5 cm)

Private collection

[4]

Untitled

1969

Porcelain and lusters

7 x 14 (diam.) in.

(17.8 x 35.6 cm)

Collection of Jane Livingston,

Washington, D.C.

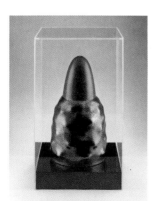

[5]

Lollycock (Dento)

1968

Porcelain, lusters, and Plexiglas

14½ x 9 x 9 in. (with base

and cover)

(36.8 x 22.9 x 22.9 cm)

Private collection

Page 16

Griffith, Hal Riegger, and Paul Soldner. (Soldner is credited with the development of the American version of the traditional Japanese raku technique.) The two pieces were included in the first national invitational survey exhibition of contemporary raku, which was organized by Fidel Danieli at California State University, Los Angeles, in 1968. *Hair Pie* is a previously unexhibited work from Saxe's pie series.

Many of these early works used reflected light and distorted images of the surrounding environment as abstract compositions in a visual field determined by the object. The simplest forms, the domes [4], often had the most complex and painterly applied lusters. They were dependent on ambient light and a large uninterrupted wall space to achieve their full effect. The manipulated forms with protrusions and rougher glaze textures had simple but highly reflective lusters. As the viewer moved around them, the reflected shapes and patterns also moved.

Jane Livingston was an associate curator of twentieth-century art at the Los Angeles County Museum of Art when she acquired this dome. Both she and Hal Glicksman, an assistant curator of twentieth-century art, helped curator Maurice Tuchman in the staging of the museum's 1971 *Art and Technology* exhibition. Glicksman was interested in seeking industry

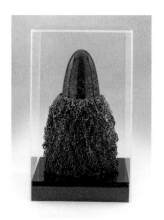

[6]

Huladick (Lavender)

1969
Porcelain, lusters, and Plexiglas
14½ x 9 x 9 in. (with base
and cover)
(36.8 x 22.9 x 22.9 cm)
Collection of Robert L. Collins

sponsorship for Saxe to work with the dome format, possibly in enameled metal. Nothing came of this proposal, largely because Saxe was just out of art school and potential sponsors wanted a more established artist. Saxe did explore several styles of mechanically reproduced domes, however.

The Lollycocks and Huladicks were a response to the prevailing fetish finish school. These works focused on commercial techniques and the activation of space. The Plexiglas covers were intended to declare a precious identity for the objects by distancing the viewer from the tactile surfaces. Contrary to what many assumed, the covers were not motivated by the need to protect the pieces, even though the hairy Huladicks are fragile. Saxe wanted to make larger, wood-framed, individual display cases for them, much like those used to display Japanese kabuki dolls.

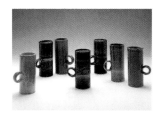

[7]

Collection of Mugs

1971–79
Porcelain
Each: 5 x 3½ x 2¼ (diam.) in.
(12.7 x 8.9 x 5.7 cm)
Private collection

The making of thousands of mugs kept Saxe from needing to take a day job to support his studio work. They also provided a format to test glazes and try out tricky firing techniques. Designed for utilitarian function, the mugs balance well, their handles being close to the center of gravity. The grips are shaped and positioned so that fingers do not rest against the side of the cup, helpful when drinking a hot beverage. The small mouth helps keep warm liquids from cooling.

[8]

Collection of Shallow Bowls

1972–79

Porcelain

Each: approx. 2 x 7 (diam.) in.

(5.1 x 17.8 cm)

Courtesy of American Hand

Plus, Washington, D.C.

Like the mugs, the bowls were basic income producers for the studio and provided the opportunity to work out formal and technical problems on pieces that did not require a large amount of time for shaping. Some of the glazing schemes were much more complicated than those seen in these examples.

Saxe's first bowls were made in porcelain, stoneware, and raku. They were all of similar size and complexity, all one-of-a-kind, and all made for sale, not as part of more ambitious creative research. He used porcelain for some of them because of the potential for exploiting certain glaze effects and color systems, like celadons, mat crystallines, and copper reds. Although all of these bowls required about the same amount of work (those with the carved edges being a little more time-consuming), everyone who saw them assumed that the porcelain ones were much more expensive. The potent cultural prejudices that people have about the relative prestige and value of different ceramic materials and traditions were clearly demonstrated to Saxe for the first time through dishes like these. This insight led to a long-term investigation into the emotional connection that people have with the objects they buy or aspire to own.

[9]

Covered Bowl (Nut Dish)

1972
Porcelain
3¾ x 7¾ x 7⅞ in.
(9.5 x 19.7 x 20.0 cm)
Private collection

This piece is one of a series of about twenty covered bowls begun in 1970. Expressive of Saxe's early lampoons of bourgeois decorative pottery, they are a mixture of European and American upper-middle-class kitsch and Chinese and Japanese court porcelain conventions. Saxe calls this form "an amalgam of nineteenth-century Chinese export ware for the American Midwest market as commissioned by Sears Roebuck." The two high-fire Chinese temmoku glazes might appropriately be found on Song teawares. Other bowls in this series have modeled roses—typical ornamentation on American ceramic hobbyist items—serving as handles on pieces decorated with cobalt brushwork that clearly refers to Ming blue-and-white porcelain.

[10]

Prototype Jardiniere

1971
Stoneware
6¾ x 10¾ x 9 in.
(17.1 x 27.3 x 22.9 cm)
Private collection

This work is a rejected design from a group of jardiniere samples developed by Saxe for a commission at the Huntington Library and Art Gallery. The commission called for a planter that could precisely accept and conceal the standard plastic pots used in the greenhouses and blend in with the historic Huntington collections yet still be clearly and immediately recognizable as a contemporary object.

This example was considered too elaborate. The accepted version was plain, without handles, in a slightly more simplified shape with a dark brown mat glaze, like a ceramic representation of mahogany.

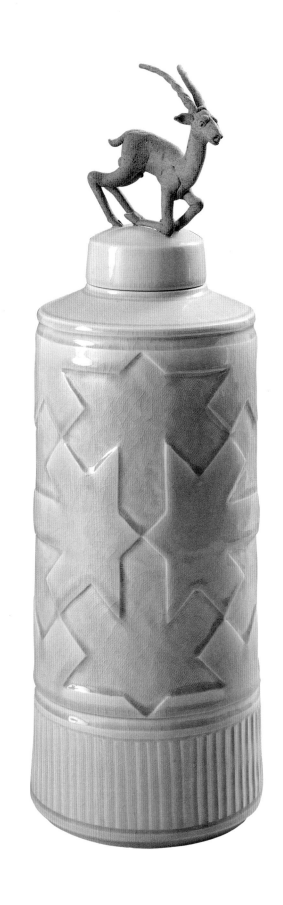

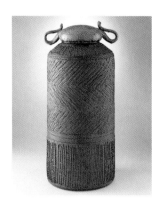

[11]

Untitled Covered Jar

1972–73
Stoneware
18 x 7 (diam.) in.
(45.7 x 17.8 cm)
Los Angeles County Museum
of Art, Smits Ceramic
Purchase Fund, M.91.104a–b

This work is part of a series of larger jars, made mostly in porcelain, that explored the possibilities of fashioning relatively thin-walled containers by rolling out a slab, forming a cylinder, and then topping it with a thrown lid.

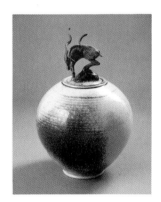

[12]

**Untitled Covered Jar with
Antelope Finial**

1971
Porcelain and stoneware
9⅛ x 7 (diam.) in.
(23.2 x 17.8 cm)
Courtesy of American Hand
Plus, Washington, D.C.

Page 23

[13]

**Untitled Covered Jar with
Antelope Finial**

1973
Porcelain and stoneware
19¾ x 6½ (diam.) in.
(50.2 x 16.5 cm)
Courtesy of American Hand
Plus, Washington, D.C.

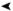

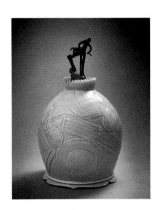

[14]

**Untitled Covered Jar with
Antelope Finial**

1979
Porcelain and stoneware
13¾ x 8½ (diam.) in.
(34.9 x 21.6 cm)
Collection of Paul and
Elmerina Parkman

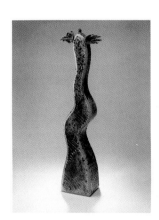

[15]

Untitled Oil Lamp

1972
Porcelain
18 x 5¼ x 3 in.
(45.7 x 13.3 x 7.6 cm)
Private collection

One of Saxe's classes at Chouinard called for the crafting of ceramic garden lamps. Rather than making banal lanterns, Saxe chose instead to design small exotic forms: lamps in the shape of shoes suitable for Ali Baba. Other of the early lamps had burners set to cast shadows made by elements of the works (such as wings, rods, and cactus stems) onto walls and tabletops. Sometimes the burners were positioned so that they could not be seen from one or more viewing angles. The play of light and shadow often created the bizarre illusion that the lamps were floating a fraction of an inch off the surfaces on which they were placed. Some burned more intensely, producing smoke that deposited carbon soot on ceramic armatures, building weird, brainlike, black lumps that eventually fell off. Yet other lamps had globs of opalescent glaze dripping from tonguelike appendages. Saxe also made tall lamps with large cactus stems that

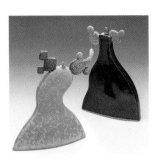

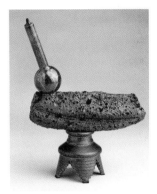

had burners at the points where one would expect to see flowers.

The oil lamps presented problems in the marketplace. Galleries could not provide a darkened environment with relatively still air that imitated the intimate and private viewing conditions required for maximum effectiveness. Many did not want the lamps lit while on display; exhibiting forms that smoked was out of the question. Also, while copious instructions were provided with the burners, they were difficult for owners to maintain. (Saxe later invented a small removable ceramic burner that served additionally as the stopper for the oil reservoir.)

Saxe was able to mount only one exhibition that properly featured these forms, at the American Hand in Washington, D.C., in the fall of 1985. The show was installed in the exhibition area in the basement below the regular retail shop. Ed Nash, the gallery director, painted the room black, which neutralized the space and allowed the viewer to experience the theatricality and intimacy of the objects. While the show was commercially successful, Saxe has not had any other significant opportunities to see what can be done with these forms.

Like the mugs and shallow bowls, the lamps became income producers for Saxe's studio. Each piece was unique, but there were distinct series with similarities in shape or format. To enhance the initial visual appeal of these objects, Saxe developed them as

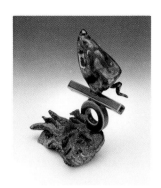

[19]

Untitled Oil Lamp (Chili)

1985
Porcelain and stoneware
6½ x 5½ x 3½ in.
(16.5 x 14.0 x 8.9 cm)
Collection of Mr. and Mrs.
Victor Sandoval

Page 26

small sculptural forms with attachments considered primarily for their formal qualities and compositional possibilities rather than for their potential to generate the effects described above. The oil lamps in this exhibition are typical of these studio works.

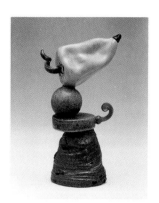

[20]

Untitled Oil Lamp (Chili)

1986
Porcelain, stoneware, and
lusters
6¼ x 2¾ x 2¼ in.
(15.9 x 7.0 x 5.7 cm)
Collection of Dawn Bennett
and Martin J. Davidson

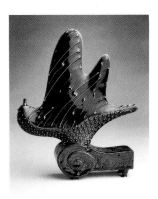

[21]

Untitled Oil Lamp
1985
Porcelain, stoneware, and
lusters
11½ x 10 x 2 in.
(29.2 x 25.4 x 5.1 cm)
Collection of Dawn Bennett
and Martin J. Davidson

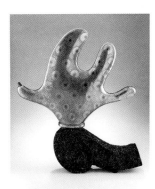

[22]

Fish Oil Lamp
1988
Porcelain, stoneware, and
lusters
15½ x 15 x 2 in.
(39.4 x 38.1 x 5.1 cm)
Los Angeles County Museum
of Art, gift of Howard and
Gwen Laurie Smits,
M.90.82.46a–b

Page 27

For many years Saxe wanted to experiment with shapes suggested by the tropical fish he had seen daily while skin diving in Hawaii during the early 1960s. After returning from his residency at Sèvres, he began working with specialized industrial and medical gloves, many of which were rigid enough to stand upright on their cuffs. These handlike shapes resembled kelp and other underwater forms seen on the reef. Saxe modeled directly from these gloves in rigid foam or plaster for translation into slip-casting molds. (Shapes like these were difficult to make directly with thin slabs, and other direct forming methods resulted in heavier masses that slumped and warped during firing.)

The bases for this series of oil lamps are similar to the "couch arms" used as stands for some of the mortar bowls (see [36]), except here they are stoneware (heavier and stabler than raku). The lamp and base were usually joined together during forming and fired as one piece; occasionally the multiple luster firings required for the porcelain lamp necessitated that it be glued onto the base after the glazing process was completed.

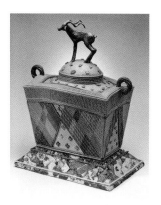

[23]

**Untitled Covered Jar on Base
with Antelope Finial**

1976
Porcelain and stoneware
18 x 13 x 9 in.
(45.7 x 33.0 x 22.9 cm)
Collection of Jeffrey Klawans,
Los Angeles

This piece was Saxe's first successful iteration of an elaborated antelope jar. The addition of a separate base allowed him to further layer the visual information presented. This was also one of the earliest pieces employing porcelain coils on the surface. The color was mixed into the porcelain before extrusion; the coils were then applied strip by strip to the surface. The last additions were the handles and finial.

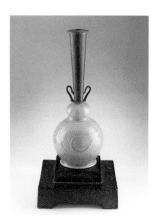

[24]

Bottle and Stand

1979
Porcelain and raku
15 x 7¼ x 7¼ in.
(38.1 x 18.4 x 18.4 cm)
Collection of Alan and
Elizabeth Mandell, Los Angeles

Bottle and Stand is the result of Saxe's exploration of presentation strategies (something also seen in the oil lamps). While not dependent on its base, the bottle was "presented" by the square, stepped raku stand. Some of the works in this series were gourd or dumbbell shaped and had tripodlike legs attached to the body, creating an open space beneath the form.

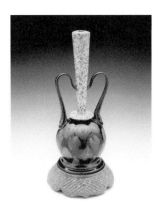

[25]

Bottle and Stand

1979
Porcelain and raku
14 x 6½ (diam.) in.
(35.6 x 16.5 cm)
Collection of Toru and
Judy Nomura Iura

Page 29

In 1973 Saxe saw the exhibition *Ceramic Art of Japan: One Hundred Masterpieces from Japanese Collections* at the Los Angeles County Museum of Art. Edo-period artists represented in the show included Nonomura Ninsei, Okuda Eisen, Takahashi Dōhachi, Eiraku Hozen, and Aoki Mokubei. The latter's method of blending seemingly incongruous elements was of particular appeal to Saxe. The influence of this exhibition and the collection of oriental ceramics at the Huntington can be seen in the form and decorative scheme used in this work.

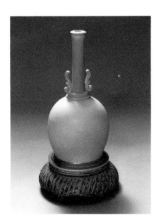

[26]

Bottle and Stand

1979
Porcelain and raku
10¾ x 5⅝ (diam.) in.
(27.3 x 14.3 cm)
Courtesy of American Hand
Plus, Washington, D.C.

Saxe made about two dozen bottles that were dependent on and compositionally inseparable from their stands. He intended to have the bases contribute to the space that the overall form occupied, each serving like an attached, massively developed foot. Some of these pieces question American craft world orthodoxies and prejudices concerning what is and is not appropriate or pure. This is clearly seen in Saxe's increased use of gold and Western European eighteenth- and nineteenth-century ornamentation juxtaposed with raku and rustic folkloric clay handling.

The partitioning of the component parts of these works, both physical (as in the bases) and visual (as in the shifts between body, neck, and handles), allowed Saxe to use a wide range of materials and forming techniques and still maintain a unified structure. The

bases, generally made of raku, were subjected to post-firing reduction of the glazes to achieve lusters and smoked black surfaces. The bottles, most often constructed of porcelain, sometimes had white or brown stoneware necks and handles. Iron filings, crushed granite, or granular copper oxide was occasionally worked into the clay before forming.

This porcelain bottle was fired in an oxidation atmosphere to above 1300 degrees Celsius; the base, of coarse earthenware made for raku, was fired in a light reduction atmosphere to about 900 degrees Celsius.

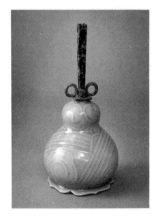

[27]

Bottle
1980
Porcelain
9 x 4⅜ (diam.) in.
(22.9 x 11.1 cm)
Courtesy of American Hand
Plus, Washington, D.C.

This gourd-shaped bottle without a base is from a series of similar forms made from 1978 to 1980. Stand-alone bottles seemed too simple to sustain interest; they had less potential to be speculatively "handled" (put into motion in the imagination of the viewer) compared with other formats Saxe explored. Bottles with stoppers and/or stands were preferred.

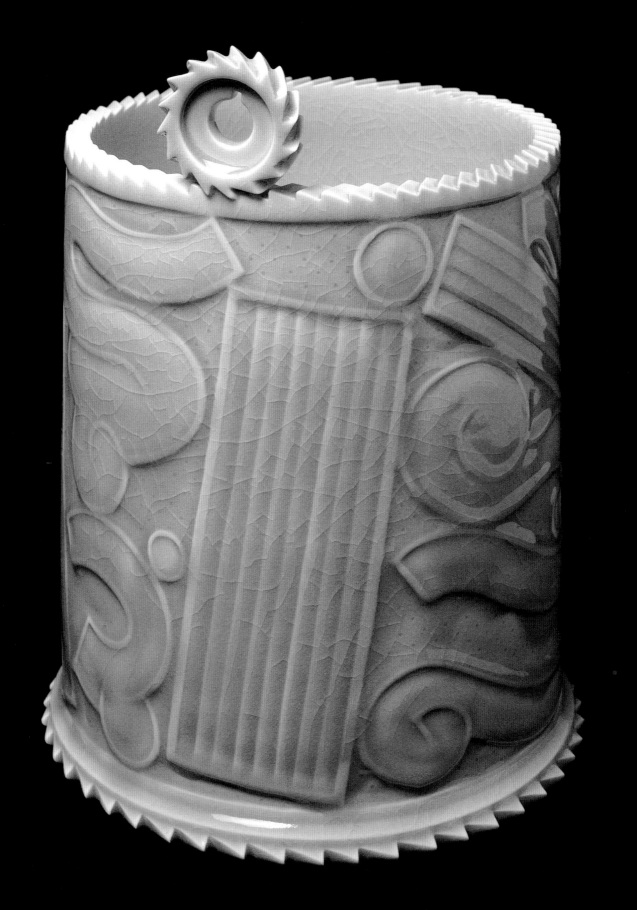

[28]

Untitled
1980
Porcelain
12¼ x 9 (diam.) in.
(31.1 x 22.9 cm)
Courtesy of American Hand
Plus, Washington, D.C.

[29]

Untitled
1980
Porcelain
12½ x 8½ (diam.) in.
(31.8 x 21.6 cm)
Everson Museum of Art,
Syracuse, New York, gift of
Social Art Club Memorial Fund
in memory of Anne Witherill
Olmstead, P.C.81.24

This is one of the first cauldrons Saxe exhibited, although he had been working on a variety of formats derived from mortars and pestles since 1976. One of six related cylinders, some with legs, this piece transformed the gears and saw blade edges used in earlier works into symbolic images of industrial power and wealth. The side milling cutter on the rim is visually incorrect, since such heads never engage a gear track, but its complexity and beauty appealed to Saxe more than a literally correct gear. (In fact, all of the serrated bowls, cups, and cylinders are laid out and cut intuitively, not by calculation or applied measurements.)

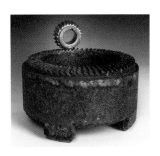

[30]

Untitled Mortar Bowl

1981

Stoneware, porcelain, and lusters

7¼ x 9½ (diam.) in.

(18.4 x 24.1 cm)

Collection of Edward Lenkin and Katherine Meier

Page 30

One of the first thick mortar bowls exhibited, this piece represents a transition from the cauldrons to the bowls with stands. Designed with low walls and legs, the coarse stoneware body (based on the clay used for sewer pipe) has a lustered porcelain gear on its rim. Formally based on flat-bottomed apothecary mortars, such works were developed at about the same time as the smaller cup-sized cylinders with serrated edges and separate bases (see [31]).

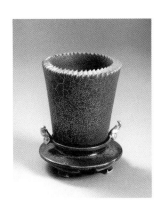

[31]

Untitled Mortar Bowl with Stand

1981

Porcelain and lusters

5⅜ x 3¾ (diam.) in.

(13.7 x 9.5 cm)

Courtesy of American Hand Plus, Washington, D.C.

Page 30

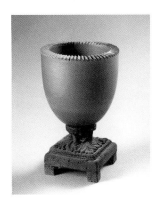

[32]

Untitled Mortar Bowl with Stand

1980

Porcelain and raku

5 x 3⅛ (diam.) in.

(12.7 x 7.9 cm)

Courtesy of American Hand Plus, Washington, D.C.

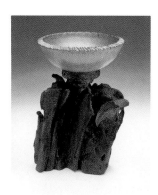

[33]

Untitled Mortar Bowl with Stand

1983

Porcelain, raku, and lusters

6¼ x 4½ x 4½ in.

(15.9 x 11.4 x 11.4 cm)

Private collection

[34]

Untitled Mortar Bowl with Stand (Big Red)

1987

Porcelain, raku, and lusters

17 x 19½ x 12 in.

(43.2 x 49.5 x 30.5 cm)

Collection of Larry and Sandra Zellner

Big Red is the largest assembled mortar bowl and stand. It is one of several intended to look markedly different from front to back. (Saxe conceived of them as being placed in an open space away from walls.) When viewed from one side, the cup seems to float above the base; from the other side, it is securely nested. When the stand was being formed and the clay was wet, it weighed about seventy pounds. Special rigging was required in order to move it into a post-firing reduction chamber while red hot.

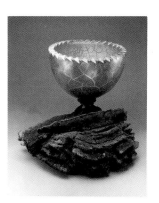

[35]

Untitled Mortar Bowl with Stand (Boudin Noir)

1987

Porcelain, raku, and lusters

14½ x 16½ x 12 in.

(36.8 x 41.9 x 30.5 cm)

Collection of Nanette L. Laitman

Page 32

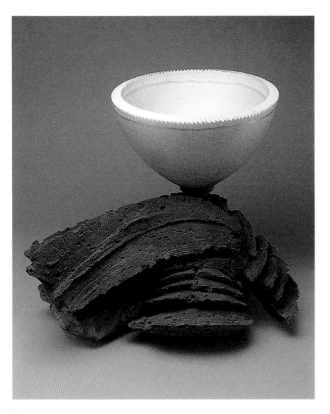

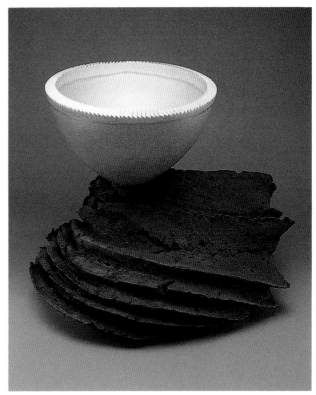

Front *Back*

[36]

Untitled Mortar Bowl with Stand

1983
Porcelain, raku, and lusters
12¼ x 13 x 11½ in.
(31.1 x 33.0 x 29.2 cm)
The Eli and Edythe L. Broad
Collection

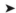

The "couch arm" pieces have a directional orientation to the room and the viewer. While the bowl is symmetrical and nondirectional, the platform supporting it extends out in a straight line.

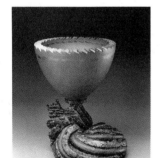

[37]

Untitled Mortar Bowl with Stand (Platinum Blue Mist)

1987
Porcelain, stoneware, and lusters
12 x 10 x 9 in.
(30.5 x 25.4 x 22.9 cm)
Collection of Fern and
Richard Simon

Page 126

This evocative mortar bowl has a stoneware stand. Stoneware, perhaps ten times as strong as the raku body used for other bases, allowed for a smaller cup support and, ironically, a base that appeared more delicate.

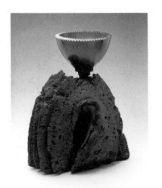

[38]

Untitled Mortar Bowl with Stand

1987
Porcelain, raku, and lusters
9⅝ x 8 x 7 in.
(24.4 x 20.3 x 17.8 cm)
Collection of Vincente Lim and
Robert Tooey, Philadelphia

Page 127

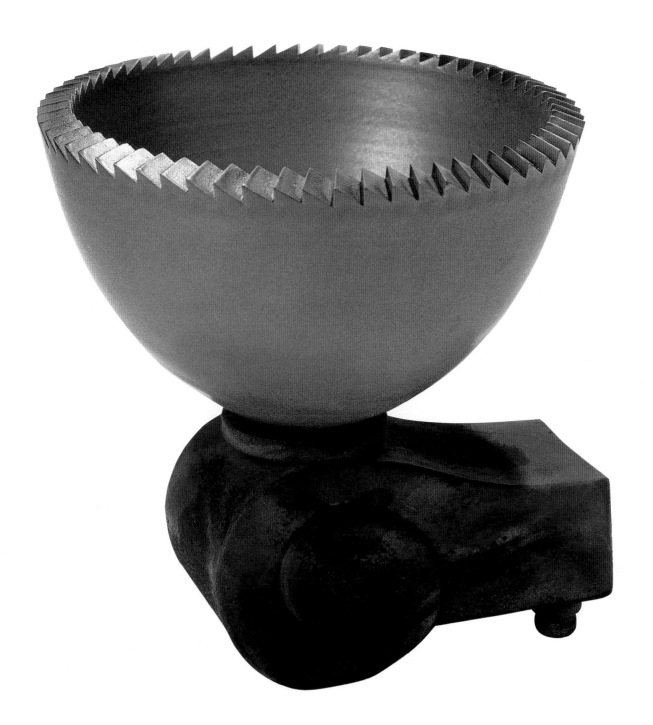

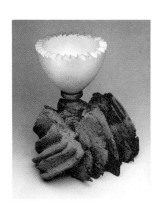

[39]

Untitled Mortar Bowl with Stand

1983

Porcelain, raku, and lusters

6¼ x 4¾ x 4½ in.

(15.9 x 12.1 x 11.4 cm)

Private collection

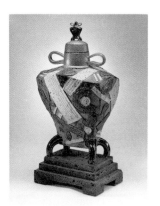

[40]

Untitled Covered Jar on Stand

1980–82

Porcelain, raku, and lusters

20⅛ x 10½ x 7¾ in.

(51.1 x 26.7 x 19.7 cm)

Collection of George and Marie Andros

Saxe constructed this unique piece as an experiment. He wanted to see if the form, with its little legs supporting the top-heavy jar, would survive firing. The difficult and time-consuming slab-building process necessary for the construction of the work led him to apply his knowledge of molds to the technical demands of this shape. Future torso jars were mold made.

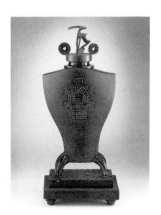

[41]

Untitled Covered Jar on Stand with Antelope Finial (Lucas)

1983

Porcelain, raku, stoneware, and lusters

23½ x 10½ x 6½ in.

(59.7 x 26.7 x 16.5 cm)

Collection of Mr. and Mrs. Leslie A. Ball, Greenwich, Connecticut

Page 34

The intention of this piece and others with illusionistic or visually complex images is to motivate the viewer to try to understand the puzzles and symbols. The hope is that he or she will become engrossed enough in interpreting this information to lose track for a moment of the pot as a whole. This updating of the ceramic tradition of trompe l'oeil attempts to fool the mind as well as the eye.

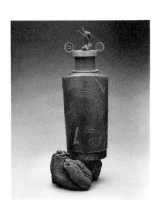

[42]

**Untitled Covered Jar on Stand
with Antelope Finial**
1982
Porcelain, raku, stoneware, and
lusters
26 x 9 x 9 in.
(66.0 x 22.9 x 22.9 cm)
Private collection

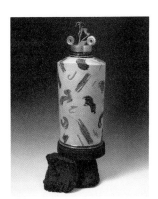

[43]

**Untitled Covered Jar on Stand
with Antelope Finial**
1983
Porcelain, raku, stoneware, and
lusters
29⅛ x 12¼ x 9 in.
(74.0 x 31.1 x 22.9 cm)
Collection of Lin Lougheed,
Washington, D.C.

Page 34

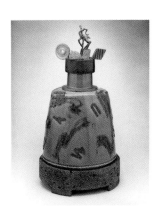

[44]

**Untitled Covered Jar on Stand
with Antelope Finial**
1982
Porcelain, raku, stoneware, and
lusters
19½ x 10 x 11 in.
(49.5 x 25.4 x 27.9 cm)
Collection of Alan and
Elizabeth Mandell, Los Angeles

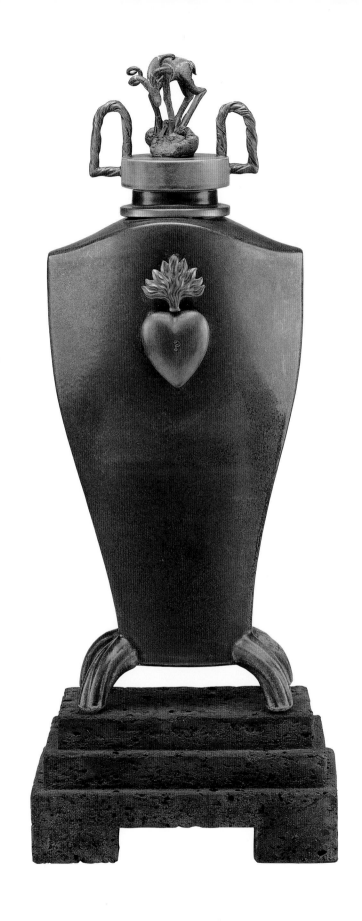

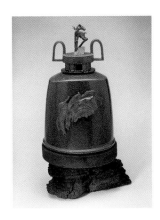

[45]

Untitled Covered Jar on Stand with Antelope Finial

1985
Porcelain, raku, stoneware, and lusters
23 x 11¾ x 10 in.
(58.4 x 29.8 x 25.4 cm)
Collection of Howard and Gwen Laurie Smits, Montecito, California

Page 133

[46]

Untitled Covered Jar on Stand with Antelope Finial (Sacred Heart)

1984
Porcelain, raku, stoneware, and lusters
26½ x 10½ x 5½ in.
(67.3 x 26.7 x 14.0 cm)
Collection of Katherine and Anthony Del Vecchio

[47]

Sacred and Profane (Garniture)

1973
Porcelain
Each: 27 x 7 (diam.) in.
(68.6 x 17.8 cm)
Courtesy of American Hand Plus, Washington, D.C.

Page 40

Sacred and Profane is an interpretation of the porcelain figurines popular in eighteenth-century Europe. It is among the very few works of this kind that Saxe let out of his studio. He was especially interested in the way disparate elements were combined in complex historical garniture displays, particularly when silver or ormolu mounts were employed to tie everything together stylistically. Over time Saxe worked out a textual device to provide the conceptual framework for contemporary garnitures (see [79]).

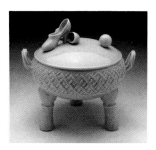

[48]

Untitled Covered Vessel (Ting)

1973
Porcelain
10½ x 13 x 12 in.
(26.7 x 33.0 x 30.5 cm)
Los Angeles County Museum
of Art, Smits Ceramic Purchase
Fund, AC1992.256.1

Page 41

Untitled Covered Vessel (Ting) is one of Saxe's early experiments with multiple historical and cultural references. This piece draws from both high and low material traditions and art fashions and mixes ceramic techniques in an "inappropriate" way.

Saxe was profoundly inspired by Chinese bronzes of the Shang and Zhou periods (c. 1523–256 B.C.) and often quoted their shapes, form organization, and details. This piece has thrown, modeled, and slip-cast elements; some of the cast pieces came from old hobbyist molds. Saxe had begun to develop a mold library in order to construct parts with more precision and character. By slip casting, he avoided the warping and cracking of thrown and slab-formed pieces. For this work he made several molds for legs that were based on Chinese bronze vessels. The carved surface mimics plaited basket weaving.

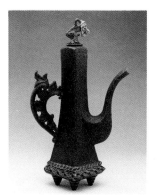

[49]

La Tour Akan

1984
Porcelain- and stoneware
12⅜ x 7¾ x 4¾ in.
(31.4 x 19.7 x 12.1 cm)
Private collection

Page 42

La Tour Akan was one of the first projects completed after Saxe returned from his residency at Sèvres in 1983–84. Garth Clark, Saxe's dealer, commissioned this limited edition, which bears the imprimatur of the gallery. (The gallery was not involved in the production, just the marketing). This project provided an opportunity for Saxe to produce something with a French theme and meet expectations that he would make new work based upon his Sèvres experience. He developed this ewerlike teapot in an edition of eight.

While each piece in the edition was superficially the same, all were unique because of the singularly crafted finials and variations in the glazes and complex gold lusters. Initially there was resistance from collectors to the idea of these wares being an edition of multiples rather than one-off pieces. Making completely handmade ceramic objects with highly variable nonindustrial processes and finishes and making them similar enough to be called an edition is many times more difficult than crafting individual objects. Multiples, however, especially as understood in the painting and sculpture market, usually have economic opportunity driving them, not interesting aesthetic problems.

[50]

Untitled Ewer (Aubergine)
1981
Porcelain
8½ x 8 x 3 in.
(21.6 x 20.3 x 7.6 cm)
Private collection

The two aubergine ewers [50–51] are part of a set of two dozen made from 1981 to 1983. The first run of fifteen in 1981 took three months of mold making, forming, glazing, and firing to produce and resulted in only two finished pieces suitable for exhibition. These works are a follow-up to a teapot format begun in 1971 whose development was interrupted by the loss of Saxe's downtown studio. Some of these earlier teapots were made with slip-cast bodies from commercial molds or from molds made of found objects, like a small pumpkin from his fiancée's garden. Hand-built and thrown spouts and various hand-built and cast handles and finials were added.

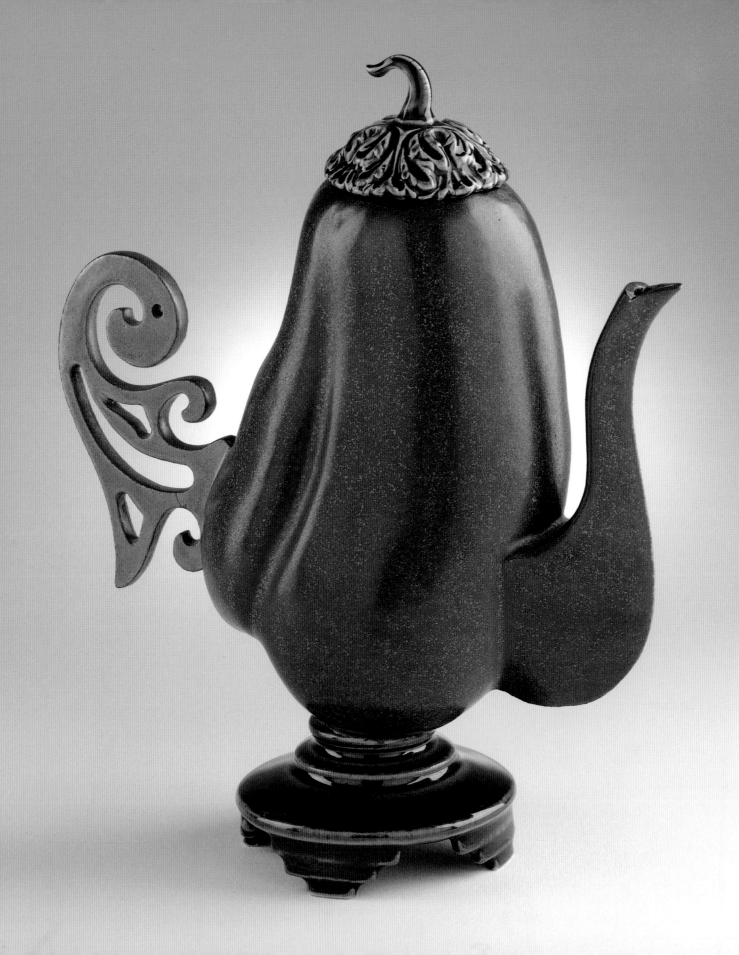

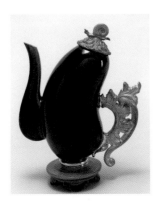

[51]

Untitled Ewer (Aubergine)
1982
Porcelain and lusters
8⅞ x 7 x 3¼ in.
(22.5 x 17.8 x 8.3 cm)
Collection of Leatrice and
Melvin Eagle, Potomac,
Maryland

Page 129

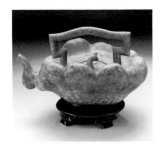

[52]

Untitled Teapot (Pattypan Squash)
1982
Porcelain
6 x 9 x 6¾ in.
(15.2 x 22.9 x 17.1 cm)
Collection of Betty Asher

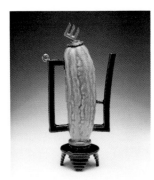

[53]

Untitled Ewer (Bittermelon)
1982
Porcelain and lusters
10¼ x 5½ x 3 in.
(26.0 x 14.0 x 7.6 cm)
Collection of Donna and
William Nussbaum

Saxe's initial understanding of the utilitarian requirements for teapots (capacity, spout size, mechanics of the handle, venting, balance, etc.) did not seem to allow for full exploitation of the very delicate and eccentric shapes of vegetables. Historically some ceramic wine ewers from China, Korea, and Persia that were derived from shapes originally made in metal presented a better example from which to work. These had more exaggerated handles and precarious spouts that directed smaller volumes of liquid in more dramatic, often ritualistic applications.

When Saxe started working again with cast vegetables in 1981, he selected exotic examples of relatively common produce available in the local supermarket. Other vegetables, such as pattypan squash (see [52]), he grew or gathered from gardens. The vegetables that inspired working molds at this time included several eggplants, summer squash, butternut and acorn squash, a small decorative gourd, a chayote, and the Chinese bittermelon (see [53]). He gradually added molds of several other squash as well as fennel (see [54]), cabbages (see [55–56]), and chilies. By 1987 he had begun making numerous molds of smaller calabash gourds, which he used primarily for ewers. While all of these teapots and ewers are inspired by historical precedents, Saxe's use of unaltered castings of found vegetables place them firmly in the present.

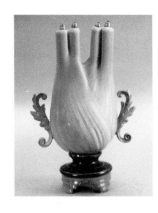

[54]

Untitled Oil Lamp (Fenouil)
1985
Porcelain and lusters
8⅛ x 5¼ x 2¾ in.
(20.6 x 13.3 x 7.0 cm)
Collection of Daniel Jacobs,
New York

Page 44

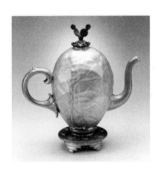

[55]

Untitled Ewer (Chou)
1989
Porcelain and lusters
8¼ x 8 x 4½ in.
(21.0 x 20.3 x 11.4 cm)
Collection of Judith Espinar
and Tom Dillenberger

Page 44

[56]

Untitled Ewer (Chou)
1991
Porcelain, lusters, and blue
sapphire rhinestones
10 x 8¼ x 4 in.
(25.4 x 21.0 x 10.2 cm)
Collection of Lynn H. Myers

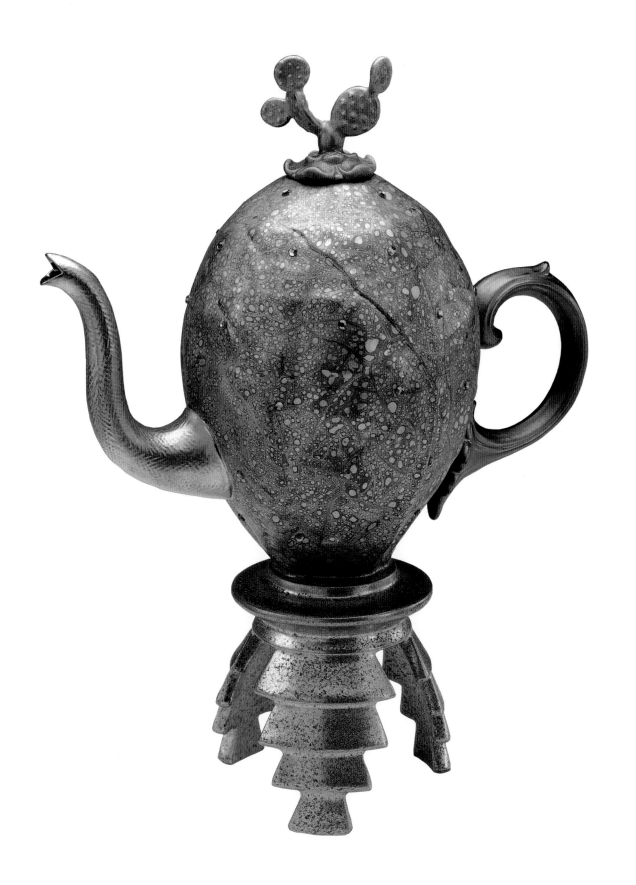

[57]

Untitled Ewer
1991
Porcelain, lusters, and antique
glass teardrop
11¾ x 6¾ x 4 in.
(29.8 x 17.1 x 10.2 cm)
Collection of George N. and
Lucille Epstein, Los Angeles

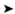

[58]

Untitled Mystery Ewer
1991
Porcelain, lusters, rose
rhinestones, fishing fly,
diode, and glass
13 x 8 x 4½ in.
(33.0 x 20.3 x 11.4 cm)
Hallmark Fine Art Collection,
Hallmark Cards, Inc.,
Kansas City

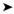

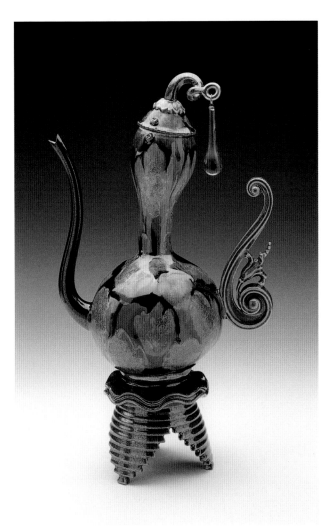 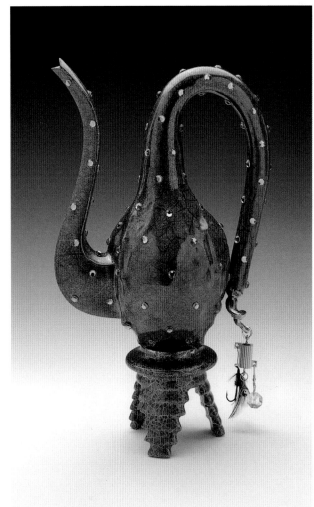

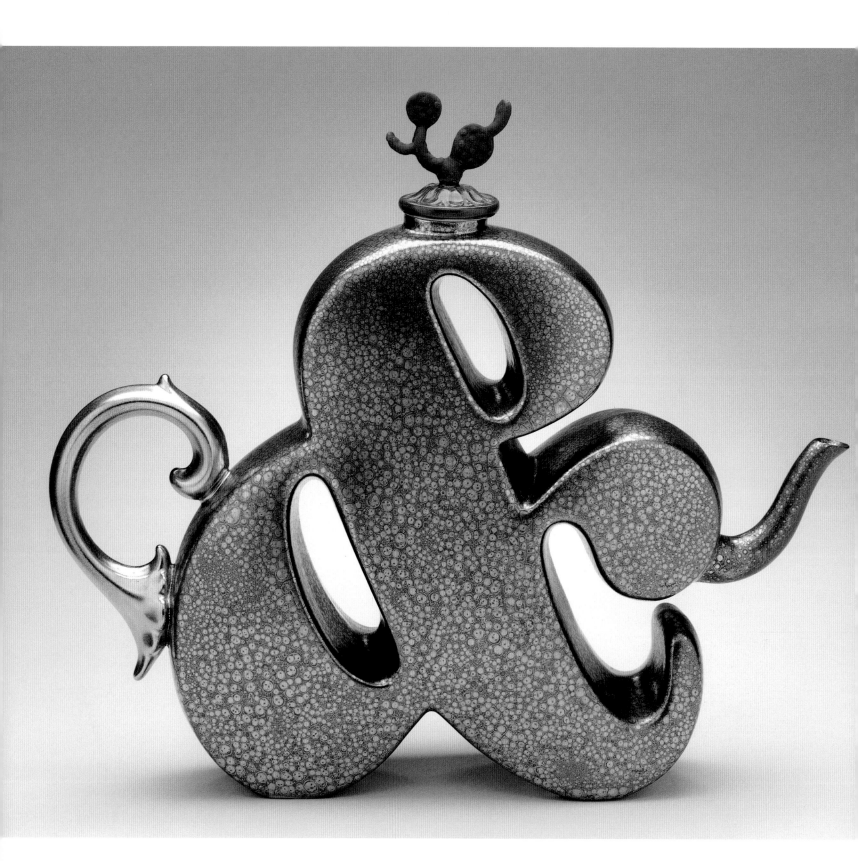

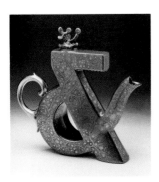

[59]

**Untitled Ewer (Clearface Gothic
Extra Bold Ampersand)**

1989
Porcelain and lusters
8½ x 9 x 2½ in.
(21.6 x 22.9 x 6.4 cm)
Private collection

Page 130

The ampersand and French curve ewers [59–62] were formed in complex multipart molds. Because the forms were too complicated to be constructed efficiently and with adequate control by direct slab or coil construction, slip-casting methods were employed.

[60]

**Untitled Ewer (Fatface Bold
Ampersand)**

1989
Porcelain and lusters
8¾ x 10½ x 2 in.
(22.2 x 26.7 x 5.1 cm)
Collection of T. Dixon Long

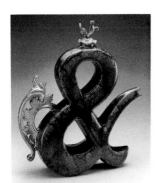

[61]

**Untitled Ewer (Franklin Gothic
Italic Ampersand)**

1989
Porcelain and lusters
10¼ x 9 x 2¾ in.
(26.0 x 22.9 x 7.0 cm)
Collection of Howard and
Gwen Laurie Smits,
Montecito, California

Page 47

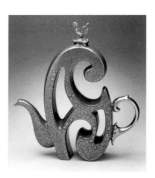

[62]

Untitled Ewer (French Curve)
1989
Porcelain and lusters
10¼ x 10 x 1¾ in.
(26.0 x 25.4 x 4.4 cm)
Courtesy of Eric J. Zetterquist

Page 47

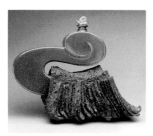

[63]

Untitled Stoppered Jar
1985
Porcelain and stoneware
13 x 16 x 7⅞ in.
(33.0 x 40.6 x 20.0 cm)
The Oakland Museum; Gift of
the Collectors Gallery
(87.14a,b)

Page 48

This work is one of a small series of thin-walled porcelain vessels formed and fired directly onto massive, solid, lavalike stoneware "anchors." The joints are vaguely inspired by the way sea anemones or coral polyps attach themselves to reefs or the way fungi and seedlings emerge from lumps of soil. The finials for this series of works are all sumptuous renderings of things that are dangerous (knives, knuckledusters, or grenades) or potentially repulsive (douche wands, snails, or pacifiers).

The full experience of these jars, or of any container with a closure, includes the mechanical operation of removing the lid, examining the interior either actually or speculatively, and then replacing the lid. With normally off-putting forms as the point of physical contact, the pieces sometimes elicit interesting reactions from viewers. While participating in the normal protocol of the informed ceramics aficionado, he or she picks up the lid or stopper in a state of distraction (similar to the habitual response of a

connoisseur of Japanese teawares turning over small tea bowls to examine the bottoms), focusing on the larger experience of the entire piece. The realization of what is being held then occurs to the person, causing all kinds of reactions depending upon what experiences and associations he or she brings to the encounter.

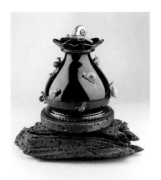

[64]

Untitled Covered Jar on Stand
1987
Porcelain, raku, and lusters
15½ x 16 x 9 in.
(39.4 x 40.6 x 22.9 cm)
Collection of Dawn Bennett
and Martin J. Davidson

Page 49

Saxe made only two pieces in this format. He originally planned to have the snails leave slime trails in mother-of-pearl all over the surface of the jar, suggesting motion. The molds for the shells were taken from actual mollusks, with the bodies modeled freehand.

[65]

Untitled Covered Jar
1985
Porcelain, raku, stoneware, and lusters
20¼ x 9¼ x 6 in.
(51.4 x 23.5 x 15.2 cm)
Collection of Beverly and
Chuck Diamond

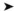

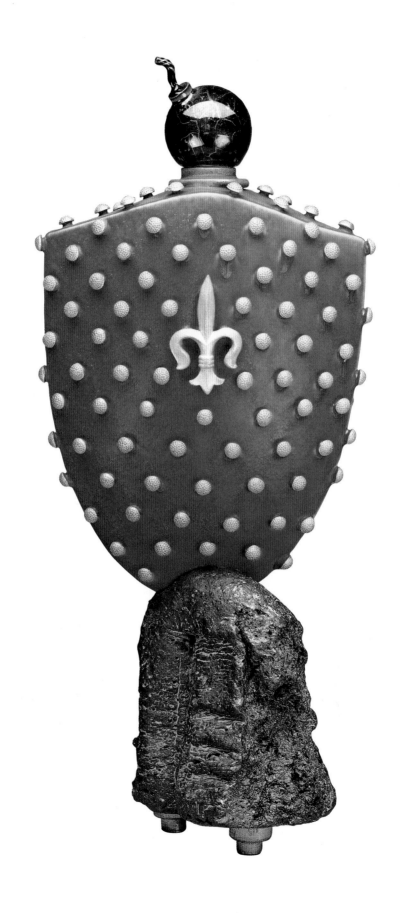

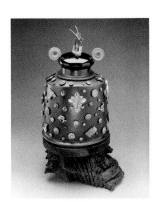

[66]

**Untitled Covered Jar on Stand
with Antelope Finial (Garth Vader)**
1986
Porcelain, raku, stoneware, and
lusters
20¾ x 12 x 11 in.
(52.7 x 30.5 x 27.9 cm)
Collection of Larry and
Sandra Zellner

Page 136

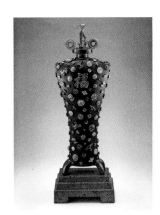

[67]

**Untitled Covered Jar on Stand
with Antelope Finial (Prosperity)**
1987
Porcelain, raku, stoneware, and
lusters
31½ x 11 x 6 in.
(80.0 x 27.9 x 15.2 cm)
Collection of Zoe and
Joel Dictrow, New York

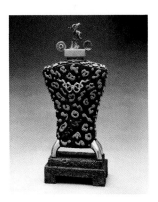

[68]

**Untitled Covered Jar on Stand
with Antelope Finial**
1982
Porcelain, raku, stoneware, and
lusters
24 x 11½ x 4 in.
(61.0 x 29.2 x 10.2 cm)
Collection of George and
Dorothy Saxe, Palo Alto,
California

A new decorative device was introduced in this piece. The floating slip-trailed "clouds" suspended slightly above the surface add to the visual complexity by providing depth. The shadows cast by the squiggles constantly change with the light. As a viewer moves around the piece, the blue decoration seems to pop out of the darker glaze surface.

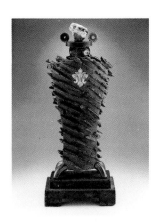

[69]

**Untitled Covered Jar on Stand
(Molly)**

1983
Porcelain, raku, stoneware,
lusters, and mineral specimen
28¾ x 10¾ x 6¼ in.
(73.0 x 27.3 x 15.9 cm)
Nerman Collection

Page 52

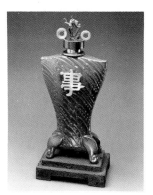

[70]

**Untitled Covered Jar on Stand
with Antelope Finial (10,000
Pieces)**

1986
Porcelain, raku, stoneware, and
lusters
22¼ x 9¾ x 6 in.
(56.5 x 24.8 x 15.2 cm)
Lent anonymously

Page 52

A found mineral specimen—a personal memento—tops this torso jar. The idea of using pots for the display of keepsakes was to be further developed in works from 1990–91. The "rocks" created in porcelain on the body are the "cargo cultist" version of the rock on the lid.

This piece is one of several larger torso jars made with slip-cast bodies. The models were inspired by earlier slab-built works but were actually carved from solid blocks of plaster. Saxe switched to this method after finding that his first attempts in this new style warped and fell over in the glaze firing. They also cracked during the application of the very complicated surfaces, which took days to execute. During the decoration process at the greenware stage, the piece had to be kept moist. This allowed the working time to be extended but exposed the piece to danger as it expanded and contracted, putting stress on the slab construction seams. This stress could also cause the piece to crack in drying and firing. As a result Saxe lost about half of the objects of this type. Some took four or five twelve-hour days to form but then broke apart. Using slip-cast bodies cut the losses to an acceptable 20 percent.

A slip-cast form does not have as much internal tension, because the walls are all of the same

thickness. The clay particles are not physically compressed, and thus chaotically aligned, as they are in individually handmade slabs. Also, since the casting is formed all at once, the moisture is consistent throughout the form.

The disadvantage of slip casting is the amount of time it takes to make a model and mold and let the form dry. Casting molds are expensive even for the simplest forms. A distinctive and immediately discernable shape can only be used a few times, even if the form, surfaces, glazes, finishes, or imagery are different, because of the strong prejudices in the art market against anything that smacks of industrial production and the expectation that art objects in craft media are strictly one-off.

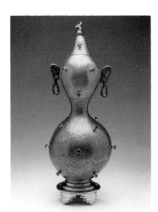

[71]

Untitled Covered Jar
1989
Porcelain, lusters, rubies, and gold
11⅞ x 4½ x 4½ in.
(30.2 x 11.4 x 11.4 cm)
Collection of Howard and Gwen Laurie Smits, Montecito, California

Page 53

Untitled Covered Jar was the first piece Saxe made with an array of jewels on the body of the form. He used them in order to posit questions about how artworks are valued. This discussion, familiar to students of material culture, is not often encountered in decorative arts objects posing as utilitarian lidded containers.

Another reason for using jewels is that they optically increase the presence of the object while complicating the viewer's task of comprehending all of the visual information. The sparkling gems compete with the curves and twists, droops and steps of the form.

The gold jewelry mounts—which enhance the presentation of the rubies—were not used on most other jars of this type. On later works the jewels were set into the porcelain, where they seem more integral. The gems on this and similar pieces are high-quality, costly synthetic stones. Saxe resisted using rhinestones until much later in the series. Although they are superficially brighter and generate more extreme optical effects, they are construed as "fake."

[72]

Shirley's Friend
1989
Porcelain, lusters, faceted cubic zirconia, and Brazilian phantom quartz crystal
21 x 13 x 9¾ in.
(53.3 x 33.0 x 24.8 cm)
Collection of Alan and Wendy Hart

➤

Gourd shapes made in ceramics and metal are among the earliest vessels; they exist all over the world in an extremely wide range of cultures, both literally reproduced and highly stylized and interpreted. Gourds are primal, infinitely variable, and beautiful.

Saxe, his wife, and father-in-law grew many of the gourds used as models. Others were bought from growers in central California, who supply them to musical instrument makers and folk artisans from Africa to Japan and to many Native American artists needing them for traditional uses.

Saxe chooses gourds based upon their suitability for specific types of pieces, with attention paid to eccentric shapes and interesting imperfections. They are used unaltered as models for molds. The model for *Shirley's Friend* was selected from several thousand gourds.

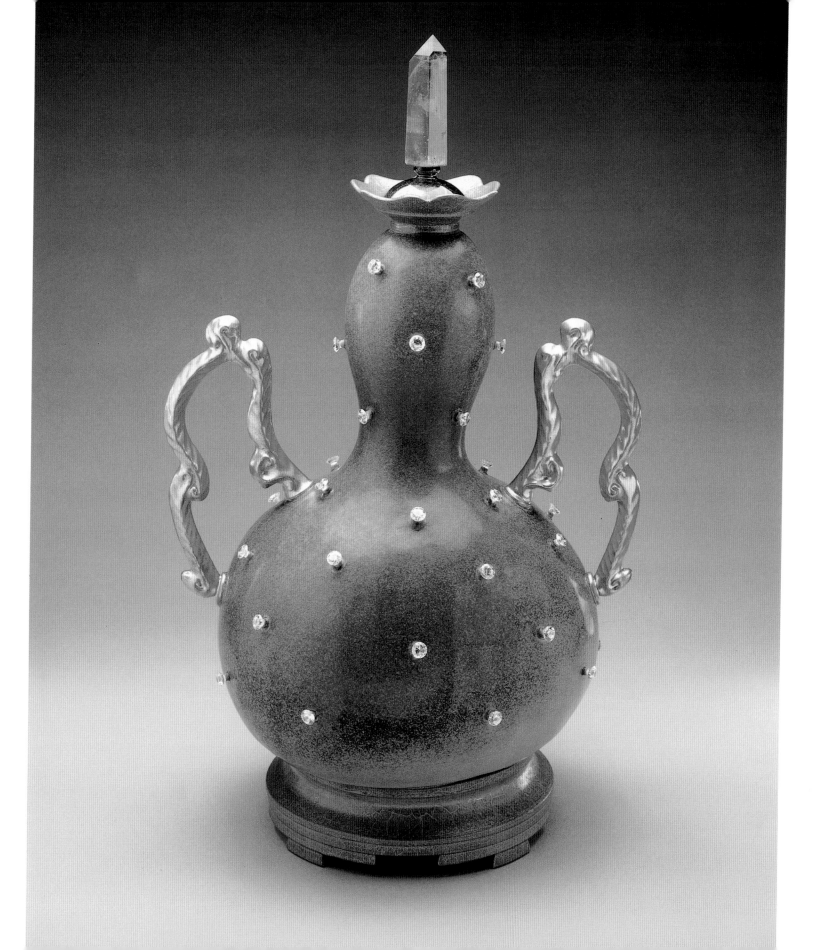

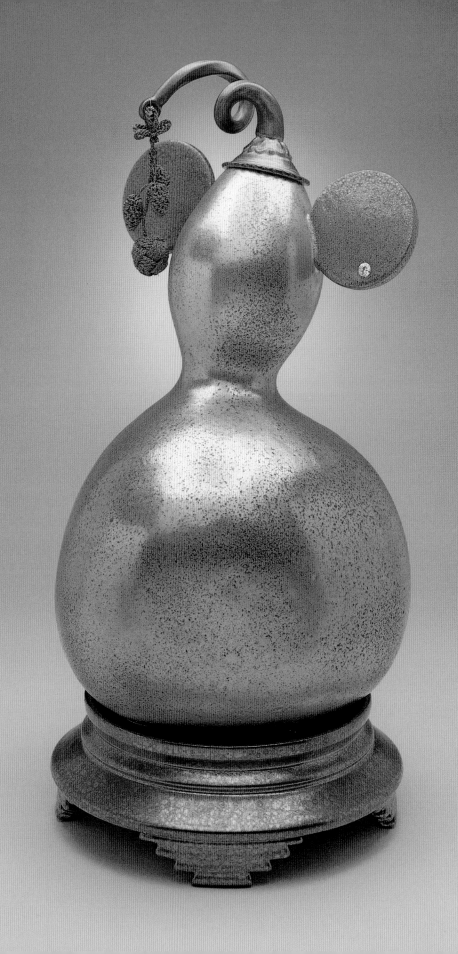

[73]

Explosive Decompression
1990
Porcelain, lusters, faceted cubic
zirconia, and quartz crystal
19½ x 10 x 8 in.
(49.5 x 25.4 x 20.3 cm)
Cooper-Hewitt Museum,
National Museum of Design,
New York

Page 139

As with *Shirley's Friend* [72], the finial of *Explosive Decompression* is made of a curious material. While quartz crystal stalactites are formed through an extremely slow accretion of waterborne silica, Saxe used this one to "cue memory or knowledge of sudden shifts in atmospheric or hydraulic pressure that squishes the guts out of fish through their mouth when they are brought up from deep water."

[74]

**Threshold of Violence
Generating Stress**
1990
Porcelain, lusters, and glass cullet
17 x 12¼ x 8¾ in.
(43.2 x 31.1 x 22.2 cm)
Collection of Mr. and Mrs.
Howard L. Ganek

Page 55

The finial of this work is an untempered chunk of glass broken out of a glass furnace. Brightly refracting and reflecting light, it is optically very flashy and sharp edged. A self-consciously careful touch is required when grasping it. Untempered glass (that which has not been carefully cooled from the molten state to room temperature through annealing) still has considerable stress that can cause it to shatter spontaneously.

[75]

Bwayne Cwazie
1990
Porcelain, lusters, faceted
cubic zirconia, and antique
French tassels
12¼ x 7 x 6½ in.
(31.1 x 17.8 x 16.5 cm)
The Arthur and Carol
Goldberg Collection

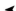

The title of this work is taken from a term coined by a six-year-old family friend with a speech problem to describe the cause of irrational behavior. From the same series as the *Dents de la mer* works [76–77], it contains strong references to popular culture. Here one of the Mickey Mouse ears sports an earring, lampooning the Disneyland policy prohibiting such displays by its male employees.

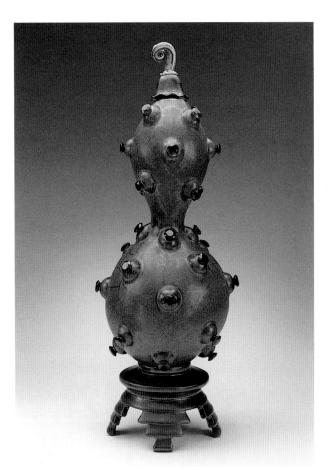

[76]

Dents de la mer
1990
Porcelain, lusters, and faceted
tourmalines
12¾ x 5 x 5 in.
(32.4 x 12.7 x 12.7 cm)
Collection of Jerome and
Patricia Shaw

[77]

Dents de la mer II
1991
Porcelain, lusters, antique glass
marbles, azurite, and malachite
19½ x 11 x 10 in.
(49.5 x 27.9 x 25.4 cm)
Collection of Gloria and
Sonny Kamm

◄

The name for both of these pieces is the French translation of the title of the American film *Jaws*. The first has a murky green glaze with twelve-millimeter tourmalines protruding from the surface. Not only sinister because of its title, the object is like an underwater mine in appearance. In the second work, glass marbles replace the gems. Chosen to contrast with the veined silver and gold surface, they show how an ordinary item can be elevated into a decorative device.

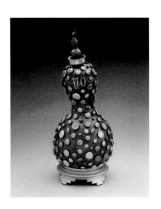

[78]

Vomiturition

1990

Porcelain and lusters

23¾ x 10 x 9½ in.

(60.3 x 25.4 x 24.1 cm)

Collection of Vincente Lim and Robert Tooey, Philadelphia

Page 141

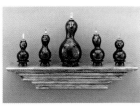

[79]

ELVIS/LIVES (Garniture)

1990

Porcelain, lusters, quartz crystals, wood, and silver leaf

32½ x 52 x 12 in.

(82.6 x 132.1 x 30.5 cm)

Private collection

Page 143

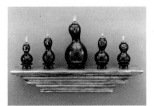

In *Vomiturition* Saxe applied his familiar button strategy to the gourd form. Press-molded versions of antique Victorian glass buttons were employed as surface elements. The title means "to repeatedly try to vomit," as one might do after eating too much rich food. Clearly the dense decoration on this piece might be too rich for some.

For at least fifteen years Saxe thought about ways to work with multiple-element garnitures. He had always been fascinated by the ormolu-mounted oriental porcelains created in Europe from the fifteenth century through the eighteenth century, particularly those fabricated in France in the second half of the eighteenth century. Many of these mounted porcelains were made in groups of two, three, five, or more, usually with different shapes within groups of three or more. Their presentation was generally symmetrical, with a centerpiece flanked by even numbers of identically shaped or sized pieces. The mounts were usually just alike or mirror images of one another; the porcelain components had painted patterns that sometimes varied considerably.

What was most intriguing to Saxe was the social and visual function of the French mounted pieces. The larger garniture sets were the most ambitious. Europeans had brought back exotic

treasures from around the world as a result of exploration and colonization. They discovered that they needed to invent presentation strategies that emphasized the rarity and value of such objects and announced the power and prestige of the owner. Gilt mounts were used to display porcelain, a new symbol of wealth and sophistication, following in the historical tradition of placing venerable relics on jeweled stands.

Some of the porcelain, particularly monochromatic celadons and whitewares from the Yuan and Ming (1271–1644) dynasties in China, were subtle, abstract, and utterly foreign to the baroque and rococo interiors into which they were introduced. Even highly decorated porcelains like blue-and-white Ming wares, elaborately enameled Qing (seventeenth and eighteenth centuries) goods, and Japanese Arita and Imari (c. 1700) works were of a different character than domestic French porcelain.

The gilt mounts were used to supply the missing form and decorative vocabulary required to fit the oriental porcelain in with the room design. The mechanical possibilities of the metal mounts and the framing of isolated elements of the total assembled vessel allowed for mixing, altering, and editing the original porcelains, including taking parts from several different pots or slicing off spouts and cutting down the original pieces before recomposing the shapes. Putting metal hinges on lids or creating metal lids

where there had been none before was another popu-
lar alteration. There were no Chinese or Japanese
precedents for any of this.

One of Saxe's primary interests in being a visiting
artist at Sèvres in 1983–84 was to create ormolu-
mounted porcelain garnitures. Because of various
problems with the organization of the program at
Sèvres (including inadequate funding), Saxe was not
able to get access to the historic models or to gain
sufficient support for foundry work. Also, although
Saxe found the historic role of ormolu-mounted
porcelain garnitures fascinating, he was not successful
in developing a contemporary expression in this
format. He could not come up with the intellectual
context that would visually tie the units of the
garniture together, ensuring that the viewer would
understand that the removal of one unit would
destroy the sense and the content of the entire group.

In 1987 Saxe discovered that text placed on a
group of jars could marry them absolutely and
provide an opportunity for presenting contemporary
ideas. Always interested in anagrams, palindromes,
and rebuses, he realized that language structures
could be equated with visual structures. The text
could provide the paradigm for ordering and reorder-
ing the visual composition of the assembled garniture.

Saxe has made nine garniture sets using anagrams.
In these pieces each vessel (a lidded jar or stoppered
bottle in a gourd form) carries one letter of the word

or expression on the front and one on the back. By switching the order of the jars or by simply turning them around, new words or symbols can be formed.

ELVIS/LIVES is a satire on all the sightings of the dead "King." The finials are quartz crystals of the type used by New Age healers and channelers. Quartz is the largest mineral constituent of both the glazed porcelain that the jars are made of and the earth's crust. The use of the crystals plays upon the notion that Elvis is ever-present and alive, whether his remains have been committed to the earth or these funerary urns.

[80]

Entre nous

1990
Porcelain, lusters, and antique
French tassel
17¾ x 9 x 7½ in.
(45.1 x 22.9 x 19.1 cm)
Collection of Douglas Peck

➤

Entre nous ("between us") is one of the first gourds to have accessory elements attached. The concept is an attempt to imply a history of use or to allow a display of an owner's personal history. The appendages function in the same way as do stamps on a passport or pictures and memorabilia placed around the edges of a dressing table mirror.

On this piece the swag cord connecting the stopper to the side of the gourd dramatizes and elaborates the action of putting the stopper in the hole. The cord, which can be repositioned, terminates in an antique tassel. Later pieces of this type have a more eclectic mixture of cord attachments.

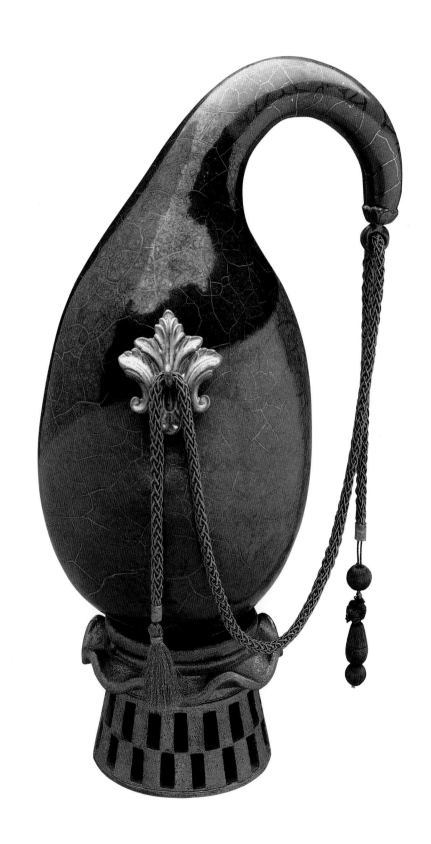

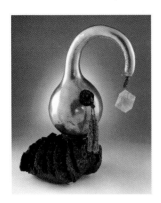

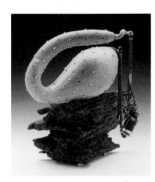

The title of this work translates as "on the tip of the tongue." It is one of several complex pieces presented as vessels of memory and magic. The potential contents for such gourd-shaped jars and stoppered bottles are determined by the user and can include everything from the ashes of a cremated pet to seed grains.

The memorabilia and "techno-amulets" hung on the forms and as fobs on the swag cords suggest talismans and fetishistic debris. Saxe's intention was to start the process of personalizing the object by putting on items that reflected his own interests and ways of putting forms and symbols together. In other works (such as [83]) he used dried flowers and fruit with the knowledge that they would eventually break off. Over time he hopes that the owner will remove any or all of the attachments and replace them with his or her own items. This strategy has been met with resistance from many collectors who are reluctant to change anything that Saxe has done. This defeats his intention.

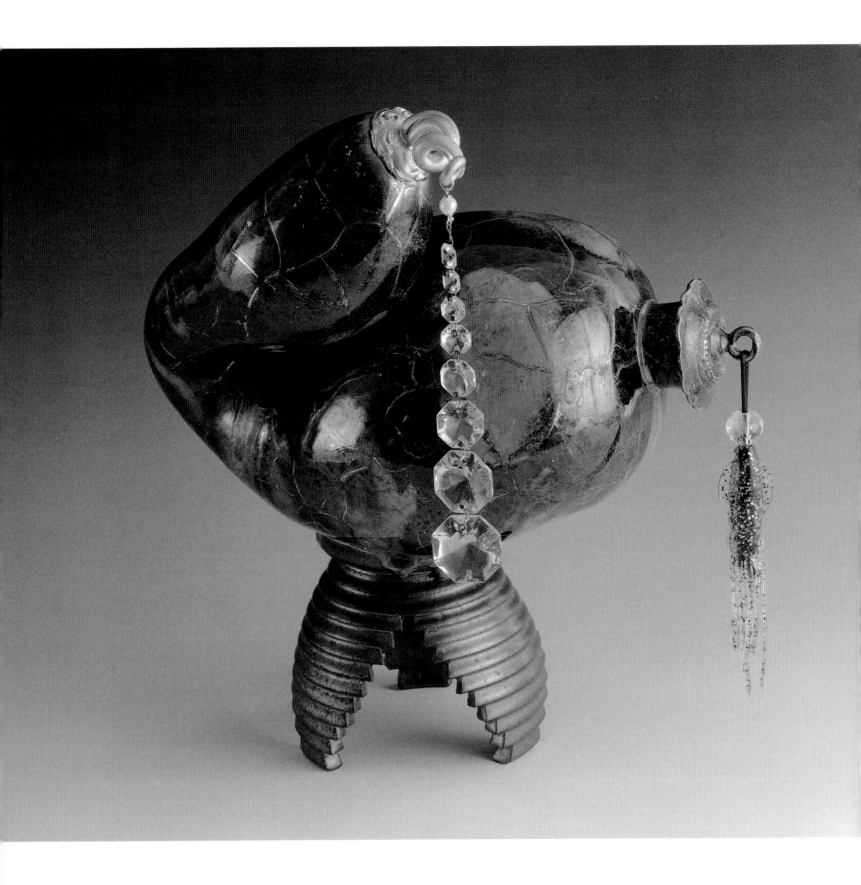

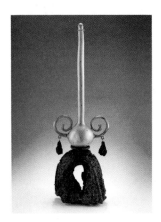

[83]

Phytogenic Object of Affection

1992

Porcelain, stoneware, lusters,
rubies, and dried pears

29½ x 10 x 7 in.

(74.9 x 25.4 x 17.8 cm)

Collection of Anne Davis

Page 58

[84]

Cacaboudin

1992

Porcelain, stoneware, lusters,
antique chandelier crystal drop,
and fishing lure

13¾ x 12 x 8 in.

(34.9 x 30.5 x 20.3 cm)

Private collection

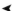

Saxe's studio resembles everything from a hardware
store to a tackle shop. His use of tassels, fishing lures,
and other such cultural debris prompts additional
"memories" or "morbid sensations."

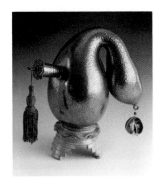

[85]

Cacaesthesia

1992

Porcelain, stoneware, lusters,
antique tassel, and desiccated
lemon

12¾ x 12½ x 7 in.

(32.4 x 31.8 x 17.8 cm)

Los Angeles County Museum
of Art, Smits Ceramic Purchase
Fund, AC1993.35.1

Page 60

Adrian Saxe and the Postmodern Vessel

Jim Collins

Considering any artist's work in reference to postmodernism has become an increasingly precarious activity in recent years, because the significance and function of the term now vary so widely. When *postmodernism* first entered common parlance in the 1980s, its definitions and applications were often contradictory. If there was any consensus among artists and critics, it was that eventually, say, by the early 1990s, a stable definition would emerge once the debate had died out and art historians had embalmed the term for future generations. In the early 1990s the debate has intensified, however, even though innumerable studies in virtually every medium and discipline have aimed at establishing once and for all the origins, evolution, and cultural significance of the movement.

The work of Adrian Saxe provides one of the richest ways to understand all three, not just because Saxe is *the* postmodern ceramist or because his vessels are some of the most refined examples of this aesthetic in any medium. What makes his body of work so compelling is that it represents the maturation of postmodernism over the course of the past two decades, moving as it does out of a dissatisfaction with modernist pieties through a contentious eclecticism to a sophisticated multiculturalism that exemplifies the nature of artistic creation and appreciation at the end of the twentieth century.

The work of any artist is, of course, understood most effectively in context, but in the case of Adrian Saxe, that sense of context is literally incorporated within the structure of the work itself. If one of the great lessons of postmodern theory is that there are no universal truths, but that all meaning and value are contingent upon specific cultural institutions that shape the resonance of any artistic text, then Saxe's work is the very quintessence of postmodern art, since it insists upon the inseparability of context from our understanding of even quotidian objects.

Saxe situates his vessels within four distinct, yet thoroughly interconnected frameworks, each mediating our encounters with his work, each given material form by the artist as an intrinsic element of the finished design: 1) a *formal* context, elaborated primarily in terms of vessel/base relationships that play with discrepancies in material, shape, and function; 2) a *transnational* context, in which Saxe juxtaposes symbols and materials drawn from different periods and national cultures, emphasizing the cross-cultural nature of contemporary artistic production; 3) a specifically *evaluative* context, in which the materiality of the vessel as artwork, as object to be collected, is emphasized through "inappropriate" combinations of precious and debased materials; and 4) a *personal* context, evident in his most recent work, which depends on the incorporation of objects that invite conjecture regarding the connections between the designs of the vessels and the life of the artist.

It is especially significant that this sort of elaborate articulation of/meditation on the variability of artistic contexts is conducted within the domain of craft, because the media that are most often associated with the development of postmodernism—architecture, literature, painting, and music—are considered the most legitimate modes of artistic expression and therefore the media most likely suited to become aesthetic battlegrounds. The craft arts, as such, have not been traditionally perceived as a "theoretical" terrain in which bold, new forms of personal expression could develop critical institutions eager to recognize, debate, and validate any "new waves" or "cutting edges." Generally perceived as *merely* functional, or even more *merely* decorative, the craft arts were condemned to second-class status once the romantic ideology of artistic genius emerged in the early nineteenth century and was then institutionalized in the twentieth, when the modernist artist was defined as a self-exiled hero possessed of Olympian sensibilities, capable of producing anything but the merely decorative. Postmodernists working in virtually every medium have challenged exactly those modernist principles that hierarchized various forms of artistic expression, which always resulted in the demonization of the decorative and the ornamental. While any number of well-known practitioners

[76] *Page 120*

Dents de la mer (detail)
1990

of postmodernism—Robert Venturi, Manuel Puig, Robert Longo, Laurie Anderson—have contested accepted notions of the tasteful and the decorative by mixing popular and high-art conventions, Saxe's work is purposely "indecorous" two times over: in his rejection of the dictates of taste and refusal to remain within the traditional confines of the decorative arts.

Throughout his career Saxe has been determined to be both a "potter" and an "artist." This dialectical relationship is not resolved in any easy synthesis but remains a highly productive tension within his body of work, a tension in which the traditional functions of ceramics are perpetually challenged although the physical characteristics of the medium are still appreciated for their own sake. Saxe's ability to successfully negotiate the age-old dichotomy between artist and craftsman depends on his sensitivity to his geographical and historical locations. Christopher Knight has described Saxe as a "global potter," a point reiterated by Saxe himself: "In a global village…we have to have new kinds of potters…. This is not tribal village art."[1] The shift in context here is fundamentally important, because it is the basis for Saxe's redefinition of the craftsman/artist opposition. He remains a potter, but within the transnational cultures of the 1980s and 1990s, a potter who can access any number of national styles and symbolic forms, from ancient Chinese to neoclassical French to contemporary flea market, at which point the distinction between potter and artist begins to dissolve as eventual function, range of inspiration, and circuit of exchange all undergo profound alteration.

The eclecticism of Saxe's vessels is attributable to two interconnected factors: the absence of an indigenous national tradition for American ceramics, comparable with the various Asian traditions, and the random access nature of cultural reference in postmodern culture. Taken together, they explain the initial impetus as well as the increasing sophistication of that eclecticism. Saxe overtly rejected the dominant tendency within American ceramics in the 1950s and 1960s, namely the wholesale attempt to make up for the lack of an indigenous tradition by imitating Asian ones, which gave rise to the ersatz orientalism that had such a stultifying

effect on American ceramics. According to Saxe, "Everybody was into that whole sensibility of Japanese tea ware, with what they called 'natural surfaces.' But for what? It wasn't for me. I mean, I live in *Los Angeles*."[2]

The alternative was to engage in a process of hypersophisticated bricolage, in which Saxe would fashion composites drawn from available materials, the difference between Saxe and the primitive artisan being, of course, the range of those available materials and inspirations. Saxe's rejection of a "pure" orientalism in favor of eclectic combinations is, interestingly, paralleled quite neatly by *Tampopo*, a recent Japanese film, a "noodle western," in which the Japanese tea-service sensibility of Yasujiro Ozu is replaced by the eclecticism of Juzo Itami, who envisions contemporary Japan as a cultural smorgasbord, part Japanese but with generous helpings of American and European culture. What constitutes "natural" or "universal" in this case becomes a matter of intense debate, inseparable from very specific cultural perspectives that render the transcendent decidedly context sensitive. As Saxe himself has said, "The only clay that was 'natural' to me was clay that was still in the ground."[3] Once formed, outside the hill, that clay takes shapes that are already culturally mediated, and in the world in which Saxe fashions his clay, collisions among those highly mediated shapes, materials, and symbols have become what is "natural" to transnational cultures. Saxe's emphasis on contextual frameworks that mediate our experience of his work is a direct response to those collisions that he incorporates into the very structure of his vessels.

Ampersand Aesthetics

The most visible clashes in Saxe's work are the (formerly) "inappropriate" juxtapositions of materials. These represent one of the most significant features in the shift from modernism to postmodernism: the move away from absolute *either/or* distinctions to *both/and* combinations. Modernism, as a movement, is obviously far too diverse in its permutations to reduce to one or two all-encompassing maxims, but one of the common denominators that appeared repeatedly in every medium was

the determination to construct strict aesthetic and ideological boundaries between avant-garde and mainstream, radical experimentation and mere "mass culture." Saxe's vessels from the early 1980s onward abandon the puritanical exclusivism of modernist ceramics by replacing the purity of faux orientalia with odd, aggressive combinations that challenge the sanctity of any and all aesthetic categories as well as the hierarchies of taste that stabilized those inside/outside, high/low distinctions.

This emphasis on amalgamation, on both/and aesthetics, destabilizes the ossified elements of style that had become the foundation of modernist decorum. Saxe's juxtapositions did more than simply contest specious notions of purity and appropriateness, however: they threw into question the functionality of the vessel. The adjoining of hitherto uncombinable styles and materials also involves a fragmentation of component parts that forces viewers to reorient themselves to functional objects that they usually encounter in various states of distraction or inattention. This amalgamation process, then, draws together and fragments at the same time, because the mixture is exactly that—a mixture, in the chemical sense of the term, in which the contours of the individual components remain distinct, an assemblage of disparate elements, unlike a solution, in which the components blend into a homogeneous new substance. To push this analogy one step further, one could argue that this distinction defines quite clearly the difference between modernist and postmodernist aesthetics, the former, obsessed with purity and transcendence, attempting to formulate solutions; the latter, concerned with hybridity and cultural specificity, dedicated to exposing conflicts and contradictions.

The initial juxtapositions in Saxe's work, the ones that have been most widely commented upon, were articulated in terms of the opposition between base and vessel. The mortar bowls, for example (see [33–39]), feature beautifully rendered clay vessels positioned on raku or stoneware bases that resemble molten lava or rough-cut stone. Saxe describes this "hierarchical organization" in this way: "The bases represent their material source, which in turn metaphorically indicates ceramic and aesthetic foundations. The vessel, on the other hand, is a more

[37] *Page 126*

Untitled Mortar Bowl with Stand
(Platinum Blue Mist)
1987

[38] *Page 127*

Untitled Mortar Bowl with Stand
1987

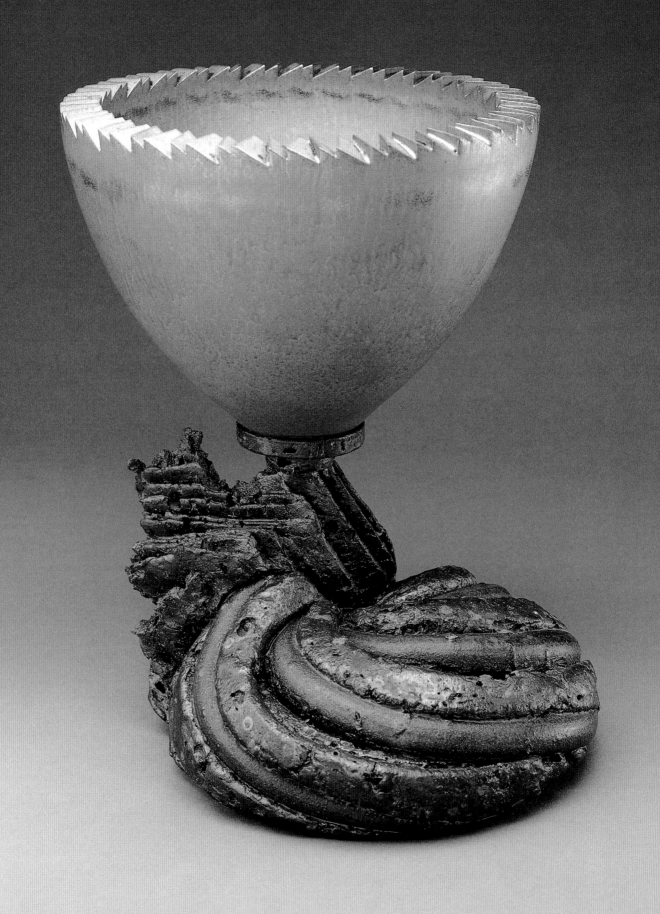

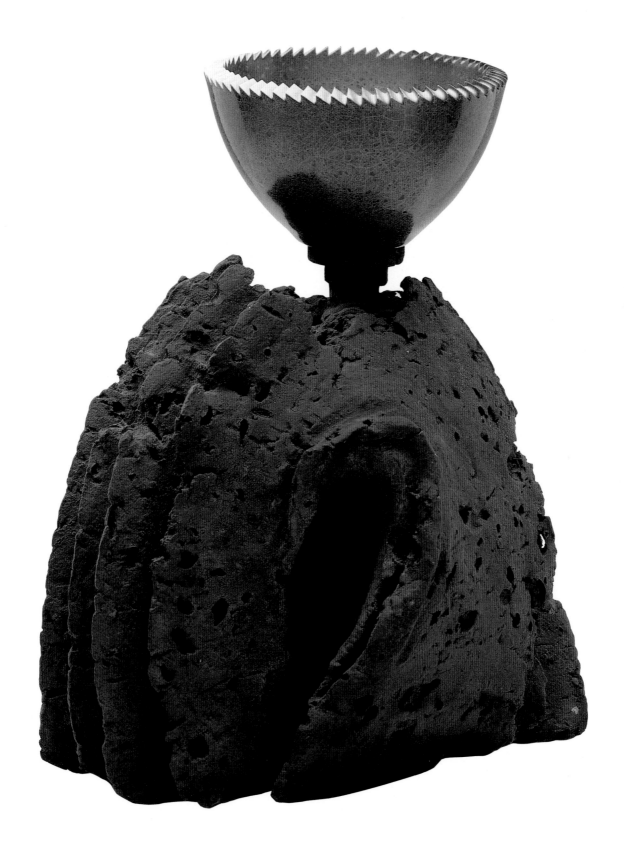

[51]

Untitled Ewer (Aubergine)

1982

refined, culturally determined manifestation of the medium."[4] As Saxe varies the relative size, shape, and material of the base vis-à-vis the vessel, the function of the former necessarily changes as it is transformed from an unobtrusive, relatively transparent support to an explicitly forefronted device that *presents* the latter.

The desire to join styles and materials in such a way that those combinations fragment the vessel into disparate components is exemplified by the *Untitled Ewer (Aubergine)*, 1982 [51]. Here the pot's standard features—body, handle, lid, and base—differ in regard to material origin and stylistic associations. The vegetable body glistens with a high-gloss glaze (a thoroughly unnatural surface for such a natural object); the handle is high baroque and originally not a handle at all, but a spare part normally used by restorers of antique furniture; the base appears to be a metallic disk resembling a manhole cover; and the lid is a gilded snail. The baroque eggplant that also happens to be a ewer becomes an elaborate visual joke, appearing to be quite literally animal, vegetable, and mineral.

The result is a work that produces mixed reactions, not, as one might expect, among different viewers, but within individual viewers. While I was writing this essay, a number of colleagues, friends, and children looked at a photo of this piece, and their reactions were remarkably similar: a spontaneous laugh followed by an expression of admiration ("It's funny, but it's really beautiful") and then a question ("What's he up to?"). This pattern epitomizes the differences between Saxe's teapot and the high modernist coffee and tea services of Harry Bertoia (FIG. 18) or Paul Lobel, in which one finds formal experimentation, but of a very particular type that generates one limited range of effects (the bold reinterpretation of the basic shapes of the various vessels was founded on geometric simplification, in which the object is reduced to an elemental shape such as a cube or sphere). This streamlining encourages the perceiver to rethink the concept of what a vessel is, just as Arne Jacobsen's *Ant Chair* (FIG. 19) and George Nelson's clocks "rethink" the function of their respective objects in terms of geometric shapes. While the modernist reduction process that attempts to purify the formal in search of

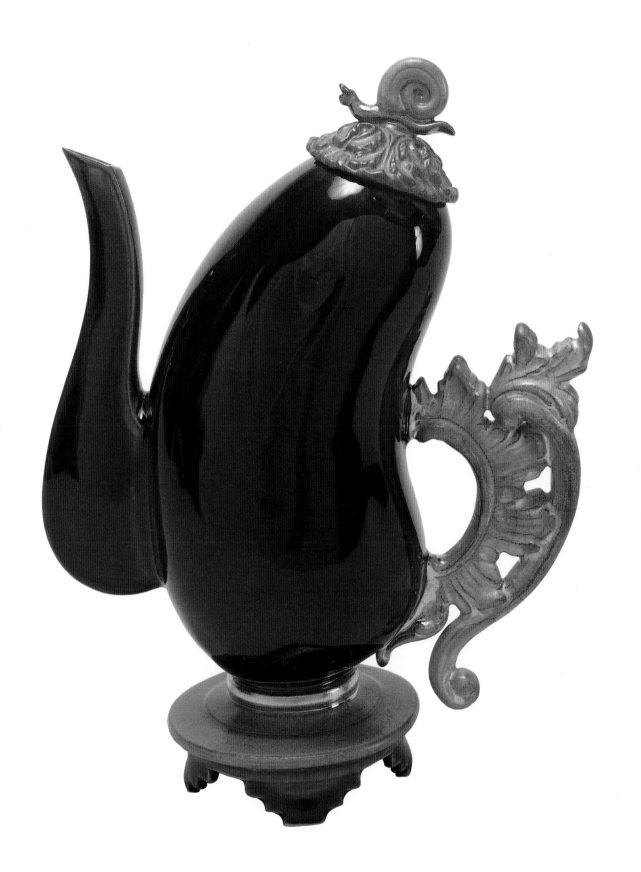

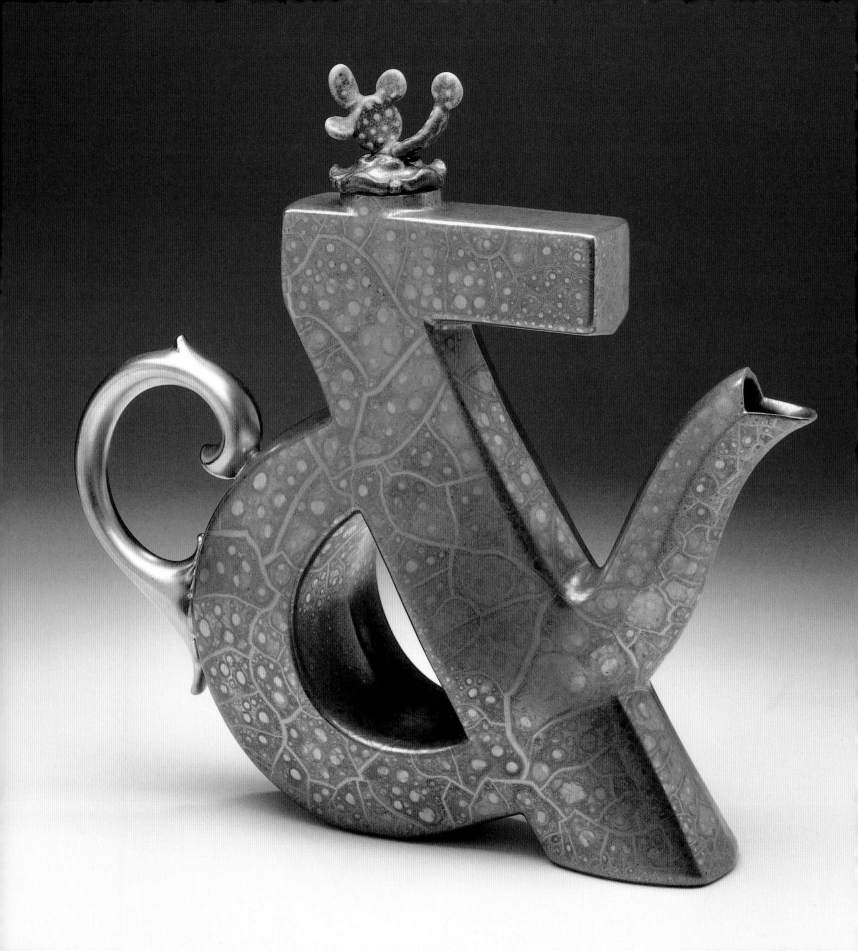

absolute function may inspire admiration, it inspires neither the amusement nor the need to interrogate intentionality in the way that Saxe's vessels do. The mixture of materials in Saxe's work generates a comparable mixture of reactions, the *Untitled Ewer* encouraging us to rethink the commonplace object not only in reference to function but also in reference to a range of other objects that are already loaded with associations and cultural significance.

The primacy of the *and*, the forefronting of discontinuity through amalgamation, is given its most explicit form in Saxe's *Untitled Ewer (Clearface Gothic Extra Bold Ampersand)*, 1989 [59]. Here the baroque handle is attached to an oversized ampersand given a luxurious finish (satin-mat glaze under a four-firing development of gold luster). A cactus—complete with "paddles" that look like Mickey Mouse ears—rests on the lid. The ampersand signifies in the most literal sense as a conjunction but also as a beautiful configuration of flowing curves, the latter impression being intensified by the richness of the surface. The combinations and conflicts proliferate throughout the piece: the lustrous surface invites tactile contact as the cactus seems to forbid it; the baroque, gilt handle is connected to a printer's mark that itself signifies connection. The ampersand is doubly emblematic and as such emphasizes the intensely "dialogic"[5] nature of Saxe's work, only here the dialogue exists not just between disparate parts but also within the body of the teapot as it resonates alternately, and simultaneously, as a literal signifier of combination and as an exquisite art object. The result is a postmodern variation on a field/ground exercise in which the same object is perceived either as a highly sophisticated visual joke or as an equally sophisticated objet d'art, depending on the contextual framework that is brought to bear.

FIGURE 19

Arne Jacobsen
(Denmark, 1902–71)
Ant Side Chair,
model no. 3100
Designed 1952
Teak-faced beech plywood, steel,
plastic sheathing, and rubber
29⅞ x 21¹⁄₁₆ x 23 in.
(75.9 x 53.5 x 58.4 cm)
The Château Dufresne, the
Montreal Museum of Decorative
Arts, Liliane & David M. Stewart
Collection, D83.124.1, gift of
Geoffrey N. Bradfield

[59]

**Untitled Ewer (Clearface Gothic
Extra Bold Ampersand)**
1989

The Transnational Style

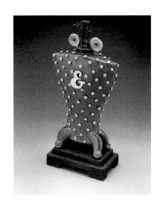

**Untitled Covered Jar on Stand
with Antelope Finial (Esperluète)**
1987
Porcelain, raku, stoneware, and
lusters
21⅜ x 10 x 5½ in.
(54.3 x 25.4 x 14.0 cm)
Pollock/Molchanov Collection

[45]

**Untitled Covered Jar on Stand
with Antelope Finial**
1985

The dialogic feature of Saxe's vessels began to take on specifically cross-cultural dimensions in the early 1980s. The mixture of cultures as well as materials, sources, and shapes is the result of the two interdependent factors already mentioned: the absence of an indigenous American ceramic tradition and the increasingly transnational nature of so many established and developing nations. Saxe's antelope jars (produced throughout the 1980s) involve a number of divergent influences and strategies. Saxe's rejection of the slavish dependence on oriental styles by American ceramists in the 1960s led him to experiment with the allegedly decadent European styles, particularly *porcelain de Sèvres*, the most notoriously decadent of them all since it was sponsored by the French monarchy for the pleasure of the court. The incorporation of European elements, however, did not result in the exclusion of Asian or American ones. *Untitled Covered Jar on Stand with Antelope Finial*, 1985 [45], for example, is shaped like a Buddhist temple bell, but the decoration quotes the brushstroke paintings of Roy Lichtenstein (see FIG. 7; page 35). That these cross-cultural combinations are another manifestation of the both/and aesthetic becomes most apparent in the *Untitled Covered Jar on Stand with Antelope Finial (Esperluète)*, 1987 (FIG. 20), in which a golden ampersand is superimposed on the side of a french blue torso jar studded with gold buttons. The overall effect is very regal and neoclassical until one realizes that the medallion originated on a typewriter and the buttons came from swap meets.

While these appropriations may throw into sharp relief the differences between modernist and postmodernist conceptions of artistic creation, Saxe himself is quick to point out the historical precedents for this sort of eclectic incorporation. His admiration for Sèvres porcelain and the European artisans of the eighteenth century arises largely in response to their willingness to borrow styles from everywhere, from chinoiserie as well as rival European schools, as they tried to develop new form vocabularies. The notion of creation as appropriation, rearticulation, and combination rather than pure invention is fundamentally premodern as well as postmodern, a point of cardinal significance for Saxe and other postmodernists who

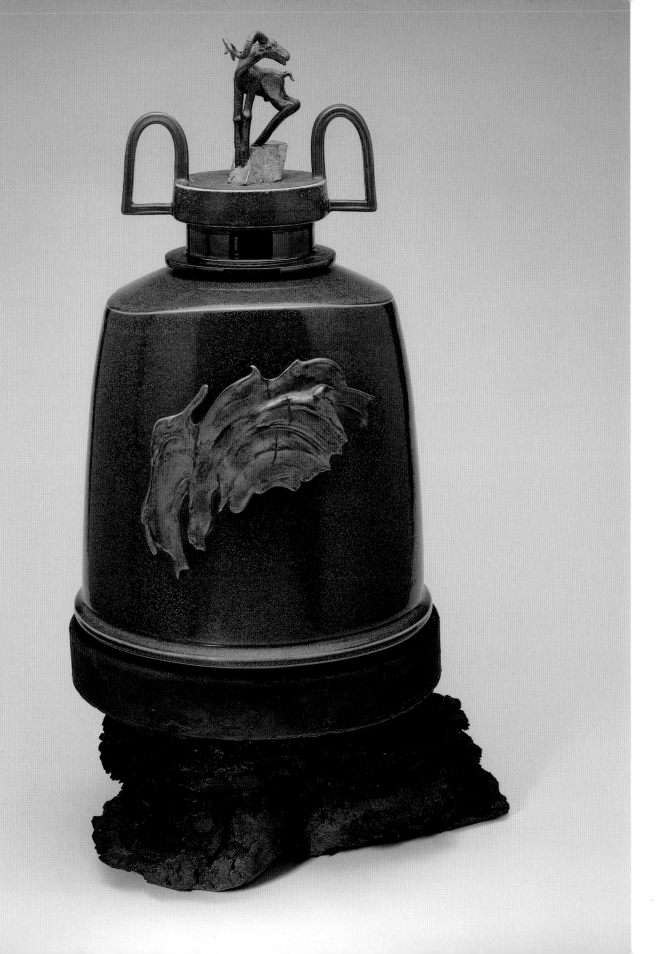

FIGURE 21
Arata Isozaki
(Japan, b. 1931)
Tsukuba Center Building
1979–83
Tsukuba Science City, Ibaragi,
Japan

maintain that this approach to composition is not a lunatic fringe aberration but instead a means of producing artistic texts far closer to the ways in which "artistry" was conceived before the rise of romanticism and its fetishizing of the unique genius of the artist. The similarity between pre- and postmodernist conceptions of artistic activity has profound ramifications, because it reverses one of the basic tenets of modernist art: the perpetual valorization of the "shock of the new" or the next new thing. By positing the modernist obsession with pure invention as a historically specific ideology of artistic value rather than as a "timeless" value essential to the production of genuine art, postmodern artists and scholars have begun to reassess both the legacy of modernism and the nature of artistic production and evaluation in the present.

While there may be premodern antecedents for cross-cultural appropriations, the transnational context of the 1980s and 1990s is nevertheless still substantially different from that of the eighteenth century in regard to the accessibility, even inescapability, of other cultures. The European chinoiserie of the eighteenth century was a response to the cultural milieu of exploration and colonization in which foreign influences were incorporated into familiar forms. The relationship between indigenous and foreign, as well as between antique and contemporary, is far more ambiguous in contemporary cultures, however, where, due to the explosion of communication technology, that which was formerly foreign may be equally, if not more, accessible than the local, resulting in hybrid forms in which both the exotic and the familiar are thoroughly intertwined threads in the fabric of day-to-day life. Saxe's vessels are directly analogous in this regard to the architecture of James Stirling and Arata Isozaki. The Neue Staatsgalerie in Stuttgart, for example, by Stirling and Michael Wilford, incorporates elements drawn from classical Greek architecture, the Bauhaus international style, and French high-tech modernism. Isozaki's Tsukuba Center Building in Ibaragi, Japan (FIG. 21), like Saxe's antelope jars, makes cross-cultural quotation the basic structuring element of the overall design. Charles Jencks has characterized Isozaki's blending of elements drawn from

Japanese, European, and American architecture as an example of what Robert Venturi has referred to as a "difficult whole,"[6] which for Venturi is what all great architecture should aspire to be, a play of complexity and contradiction.

Saxe's *Untitled Covered Jar on Stand with Antelope Finial (Garth Vader)*, 1986 [66], and the *Untitled Covered Jar on Stand with Antelope Finial (Prosperity)*, 1987 [67], are perfect examples of the "difficult whole" aesthetic brought to ceramics within a specifically transnational context. In the former, the Buddhist bell body on a raku base is studded with gilded buttons and miniature objects that look like charms on a bracelet: dogs, drums, and, most prominently, the fleur-de-lis. The title conflates the names of Garth Clark and Darth Vader. Each of the individual elements introduces a charged signifier of radically different contexts: ancient Chinese and contemporary American, natural and man-made, the art market and Hollywood film. In the second work, the Chinese character for *prosperity* is affixed to the side of a jar that is studded with buttons and charms and topped with an antelope and gears. The difficulty of each of these "wholes" is not just the mixture of shapes and materials. These jars are such complex texts, semiotically speaking, because they speak in so many different registers, each component taken out of its original context but nevertheless still carrying that context with it. Within this whole the components engage in complicated forms of cross-talk or, more precisely, encourage the viewer to fill in the contexts alluded to and in the process experience the polyphonic dissonance of different styles and institutions that constitute contemporary cultural life.

In order to fully appreciate the complexity of Saxe's work, we need to recognize the underlying changes that have occurred in our semiotic environments. The infamous "information explosion" generated by rapid development in media and computer technologies has, as it is often said, brought the world closer together, but in so doing, it has altered the ways meanings are produced by changing the accessibility of information and the ways it is transmitted and manipulated by actual speakers within a particular culture. Mary Louise Pratt has made a crucial distinction

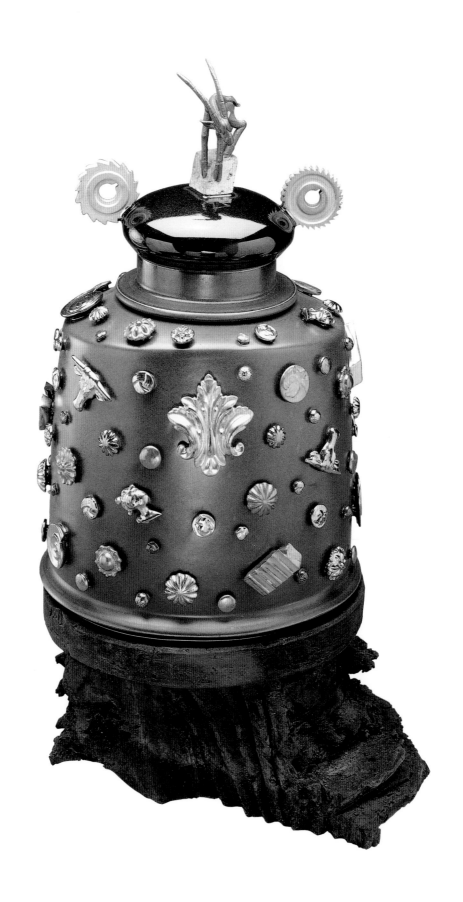

in this regard between a linguistics of *community* and a linguistics of *contact*. The former presupposes a common language of a culture-as-cohesive-community, but the latter, taking as its premise the multicultural, heterogeneous nature of most contemporary societies, focuses on "relationality," the "processes of appropriation, penetration or co-optation of one group's language by another."[7]

Saxe's vessels exemplify the linguistics, or more precisely in this case, a semiotics of contact in which different national styles, historical periods, and varying levels of cultural legitimacy, from the highest art to the lowest kitsch, now interact without a unitary hierarchy that might keep each in its place according to some absolute standard of taste. The European artisans of the eighteenth century may have adapted various national styles, but the tastefulness of the object was never in question, since the popular was banished from the world of fine art. At this point Saxe's buttons, cylinder heads, and cacti are as much a violation of the neoclassical tradition as his acts of appropriation are themselves a violation of the romantic/modernist sensibility. Saxe's vessels are produced in a world in which not only art objects but also entire cultures are difficult wholes or a series of difficult wholes.

[66]

**Untitled Covered Jar on Stand
with Antelope Finial (Garth Vader)**
1986

Cross-Talking Down at the Art Market

Perhaps the most striking feature of Saxe's antelope and torso jars of the late 1980s is not so much what they do as what they demand, namely the complicated form of cultural literacy that obviously informs them and just as obviously is demanded by them. This literacy is multicultural, although not solely in the rather limited sense that the term has acquired. It is also multicultural in regard to a knowledge of high art *and* popular culture that is required of the viewer in order to appreciate the message, a knowledge that must be accompanied by an understanding of the ways in which art circulates as a collectible object. If Saxe's mortar bowls emphasize the materiality of the ceramic object as clay, his more recent gourds stress the materiality of the ceramic object as artwork-to-be-collected.

In the late 1980s Saxe began to literalize or give physical form to another contextual framework: the world of art collecting. This explicit commentary on his vessels as luxury consumer items is evident in an antelope jar from 1987 on which the universal bar code is affixed to the side of the vessel in place of the medallions, fleurs-de-lis, and ampersands that decorate other of the jars. It is in the gourds, however, that Saxe has most thoroughly elaborated his perspectives on the nature of artistic evaluation. The cross-talking begins with the use of humble, home-grown vegetables as the models for the molds. The gourds are then covered with extremely sophisticated finishes of gold and silver and studded with materials that accentuate their glitz, from faceted cubic zirconia to antique marbles to gold plastic letters normally found in hardware stores and craft shops of the kitschiest variety. The use of "precious" stones in *Untitled Covered Jar*, 1989 [71], forefronts the mechanisms of evaluation; the borrowed prestige of materials that have intrinsic value gives added value to the vessel, as does the use of gilded handles in *Shirley's Friend*, 1989 [72], and *Explosive Decompression*, 1990 [73].

The discrepancy between the levels of value found in shape, finish, and studs is especially apparent in *Bwayne Cwazie*, 1990 [75], in which the Mickey Mouse ears, golden finish, and cubic zirconia earring create an especially noisy, dialogic cross-talk, where the value of the whole is rendered purposely absurd because that

[73]

Explosive Decompression

1990

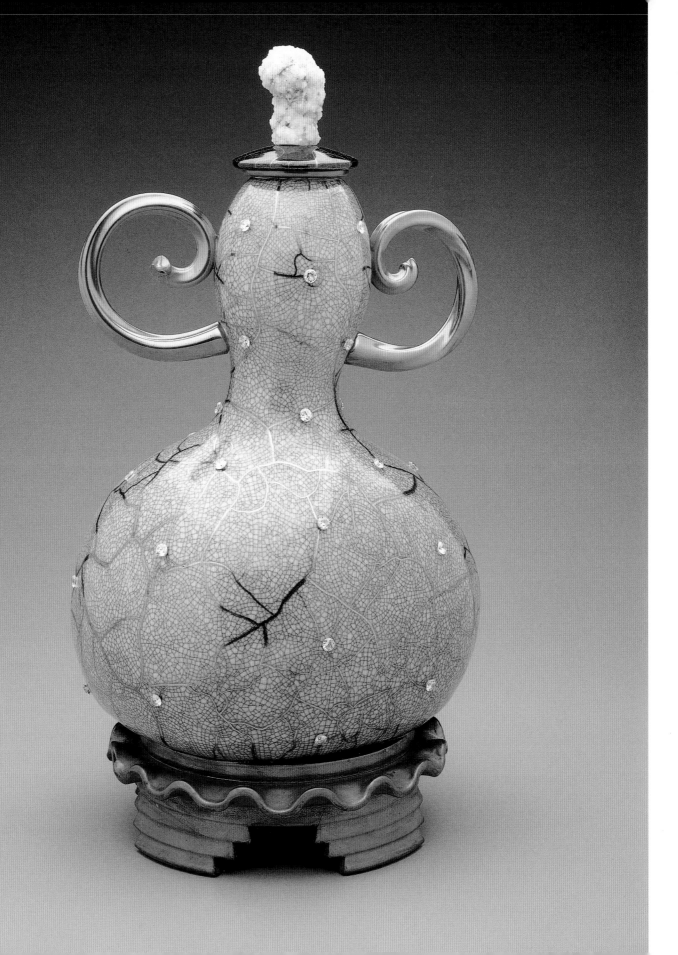

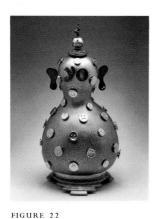

whole is so grotesque. Two gourds from 1990 take this process even further. One, entitled *Joke of Destiny* (FIG. 22), features even more ridiculous ears—pierced with precious stone earrings—and a body embedded with golden happy-face buttons. All of the elements are thoroughly luxurious yet thoroughly ridiculous. The second gourd, *Vomiturition* [78], extends the commentary on the variability of artistic value by using yet another strategy; the dialogic relationship is here accomplished through the juxtaposition of a body covered with garish gilded buttons and a lid that is a miniature version of the same gourd, only completely unadorned.

In his commentary on Saxe's use of eighteenth-century sources Peter Schjeldahl argues that the artist invokes the rococo as a critique of consumer capitalism run amok: the "expression of another culture that was going nowhere."[8] Arguing along similar lines, John Bentley Mays contends that Saxe's vessels are "oracular objects in a history of collapsing taste more general than that of prerevolutionary France—the repetitious story of the craze for frills, excess and luxury that has invariably preceded all the great revolutions and social catastrophes of the modern era."[9] While this approach to Saxe's work is convincing, it addresses only half the story. Mays's conviction that Saxe's references involve a "history of decayed taste" and that his vessels serve to condemn a culture dedicated to "the manufacture of doodads" seems overstated simply because Saxe's vessels, especially the gourds, may employ doodads and rococo stylistic flourishes, but they do so ambivalently.

ELVIS/LIVES (Garniture), 1990 [79], embodies this ambivalence toward the decadence of contemporary culture and its impact on art. Here the gourds are black porcelain with platinum lusters, developed in multiple firings, suggesting the antiquity of stains, the raw veining produced through aging. The surfaces are breathtakingly beautiful, and the elaborate silver-painted wood shelf also contributes to the overall expression of elegant refinement. The ceramic letters (modeled from industrial plastic signage) attached to the front and back of each

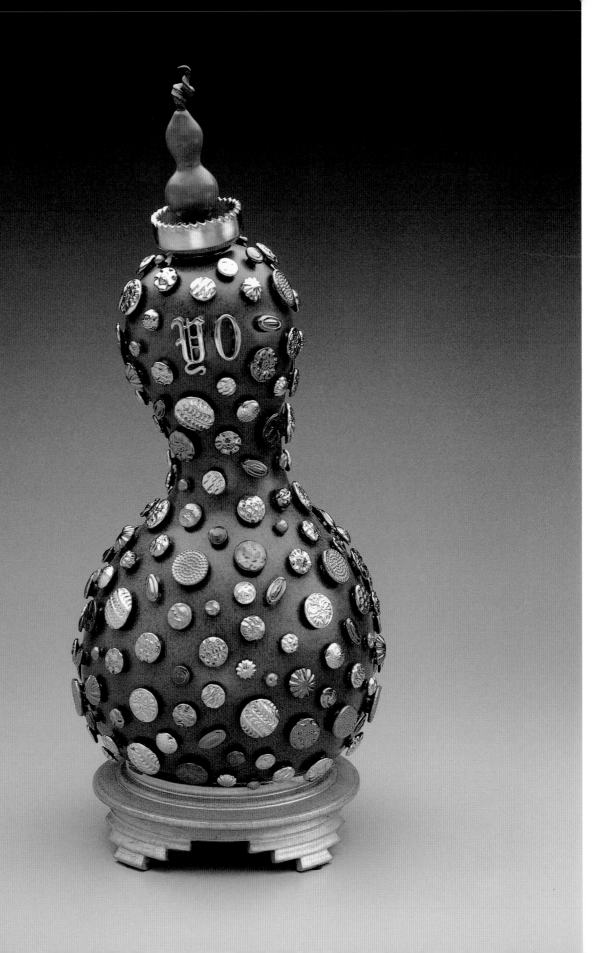

gourd directly contradict that refinement, however, by introducing the realm of "craft items," a world of craft fairs attended by people for whom the King will never die. The play on the eternal nature of royalty, whether it be Elvis or Louis, living on in our cultural memories in the forms of popular songs or fine porcelain objets d'art, could hardly be more finely wrought, nor the ambivalence more exquisitely turned.

Linda Hutcheon has argued that postmodern art is characterized by exactly this sort of ambivalent parody, a form that embodies both meanings of the Greek prefix *para*: "counter" and "beside"—a situation in which the parodic text distances itself from the original but also demonstrates some sort of affiliation with that original.[10] *ELVIS/LIVES* is a perfect articulation of exactly this sort of ambivalence, one that condemns popular and classical decadence but also relishes their excess, which, like it or not, remains extremely seductive and inevitably "lives."

Conclusion

In his most recent gourds Saxe has added a fourth contextual framework to his vessels. His work throughout the 1980s gave shape to the formal, transnational, and evaluative contexts for the meanings those works acquired as they circulated. A piece like *Sur le bout de la langue*, 1991 [82], however, introduces yet another conceptual framework: personal history.

Saxe's earlier work is seldom without historical quotations, and his eclectic combinations are most assuredly individual, but the sense of history at play is an "official" public history of artistic styles. In *Sur le bout de la langue* the history of art is augmented by personal memory. This piece may be considered a synthesis of the techniques and theoretical concerns that Saxe has been developing over the past two decades. There is the formal juxtaposition of a coarse, primal material base and finely glazed vessel and the combination of the natural vegetable form and artificial studding with blue sapphire rhinestones. The red tassel evokes European neoclassicism with its accompanying overtones of sumptuousness, but the three

[79]

ELVIS/LIVES (Garniture)

1990

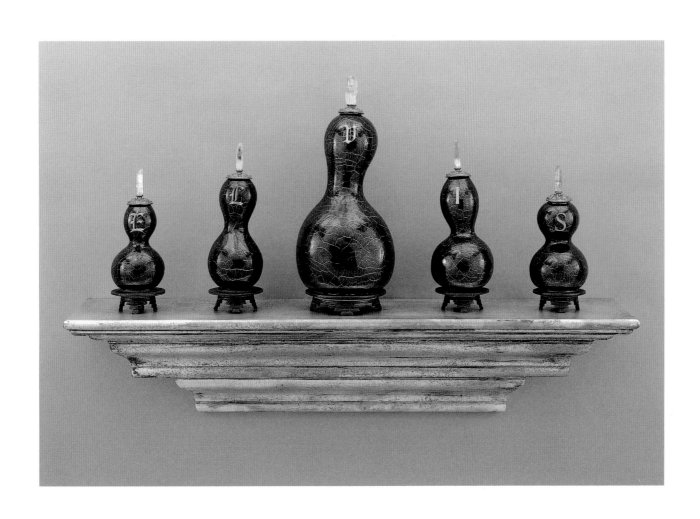

objects dangling from the tassel strike wildly disparate notes, even for someone familiar with Saxe's work. The fishing lure, potentiometer (used for trimming radio frequencies), and Peruvian talisman jar are all objects drawn from Saxe's past, objects that are in one way or another talismanic in reference to the artist's memory. Where the earlier gourds comment directly on the vessel as object of financial investment, *Sur le bout de la langue* is distinguished by the sense of personal investment, once again given precise physical form, once again introducing another dimension to ceramic art. It is this continual refinement of craft coupled with a relentless determination to push the limits of the medium as a form of artistic expression that makes Saxe's work so worthy of our own "investment" in every sense of the term.

[82]

Sur le bout de la langue
1991

NOTES

1
Christopher Knight, "The Global Potter," *Los Angeles Times*, 24 November 1991, Calendar section.

2
Ibid.

3
Adrian Saxe, interview with author, 23 May 1992.

4
Garth Clark, "Adrian Saxe: An Interview," *American Ceramics* 1, no. 4 (Fall 1982): 23–24.

5
For an explanation of the term *dialogic* see Mikhail Bakhtin, *The Dialogic Imagination*, ed. Michael Holquist (Austin: University of Texas Press, 1981).

6
Charles Jencks, *Post-Modernism: The New Classicism in Art and Architecture* (New York: Rizzoli, 1987), 297.

7
Mary Louise Pratt, "Linguistic Utopias," in *The Linguistics of Writing: Arguments between Language and Literature*, ed. Nigel Fabb et al. (Manchester, England: Manchester University Press, 1987), 59–61.

8
Peter Schjeldahl, "The Smart Pot: Adrian Saxe and Post-Everything Ceramics," in *Adrian Saxe*, ed. Craig Allen Subler (Kansas City: University of Missouri-Kansas City Gallery of Art, 1987), 15.

9
John Bentley Mays, "Stylistic Ensembles," *American Craft* 47, no. 5 (October/November 1987): 47.

10
Linda Hutcheon, "The Politics of Postmodernism: Parody and History," *Cultural Critique* 5 (Winter 1986–87): 179–207.

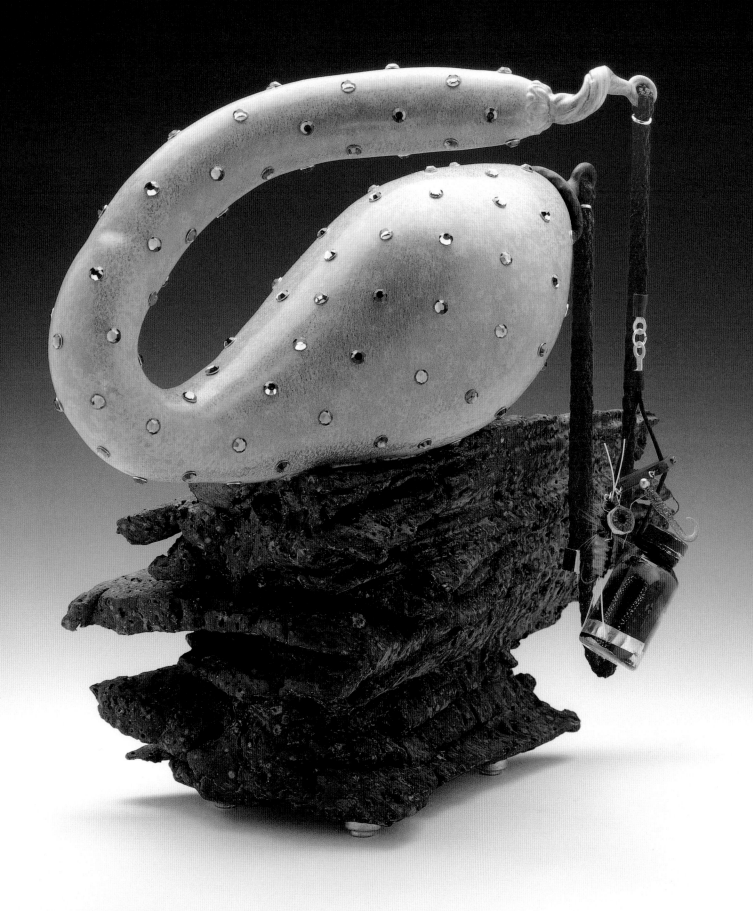

Exhibition History

NOTE: *As the title of most solo exhibitions was simply* Adrian Saxe, *only those with different titles or with subtitles are provided.*

1963

Group exhibition: Albatross Gallery, Balboa Beach, California.

Solo exhibition: Orange Coast College, Costa Mesa, California.

1968

Group exhibition: *Raku*, University Gallery, California State University, Los Angeles.

Group exhibition: *Design West*, California Museum of Science and Industry, Los Angeles (opened April 26).

1969

Group exhibition: *Porcelain '69*, The Egg and the Eye, Los Angeles (July 1–August 9).

1970

Group exhibition: *Cerritos Ceramic Annual*, Cerritos College Gallery, Cerritos, California (February 24–March 15).

Solo exhibition: Canyon Gallery Two, Los Angeles (March 8–April 2).

Group exhibition: *California South VIII*, The Fine Arts Gallery of San Diego (March 20–May 10). Brochure.

Group exhibition: *Ceramic Invitational*, Santa Ana College Gallery, Santa Ana, California (April 13–May 1).

Group exhibition: *Temple Street Artists*, Long Beach Museum of Art, Long Beach, California (October 4–November 10).

1971

Group exhibition: *California Design Eleven*, Pasadena Art Museum (March 14–April 25). Catalogue.

Group exhibition: *Ceramic Annual*, Southern Tier Art Association, Corning Museum, Corning, New York (June).

Group exhibition: *Contemporary Ceramic Art: Canada, USA, Mexico and Japan*, The National Museum of Modern Art, Kyoto (October 19–December 5). Catalogue.

1972

Group exhibition: *The Intricate Object*, University Art Galleries, California State University, Long Beach (January 30–February 24).

Group exhibition: *The Cup Show*, David Stuart Galleries, Los Angeles (October 3?–28).

1973

Group exhibition: *Contemporary Porcelain*, Philadelphia Art Alliance (May 10–June 3).

Solo exhibition: American Hand, Washington, D.C. (September 28?–October 27?).

Group exhibition: *Ceramics West*, Utah State University Art Gallery, Logan (October 1–November 14).

1976

Group exhibition: *Salute and So-Long Seventy-Six*, The Kaffie Gallery, The Carancahua Compound Center for Contemporary Art, Corpus Christi, Texas (December 4, 1976–January 7, 1977).

Group exhibition: *Porcelain*, Kaplan-Baumann Gallery, Los Angeles (December 11, 1976–January 11, 1977).

1977

Group exhibition: *Ceramic Conjunction*, Long Beach Museum of Art, Long Beach, California (March 19–April 24). Catalogue.

Group exhibition: *Drinking Companions*, John Michael Kohler Arts Center, Sheboygan, Wisconsin (October 30–December 30).

Group exhibition: *Art of the Container*, Cultural Arts Center Gallery, Veterans' Memorial Regional Park, Sylmar, California (November).

1978

Group exhibition: *Clay III*, Riverside Art Center and Museum, Riverside, California (October 14–November 9).

Group exhibition: *Clay Encounter*, Beaumont Gallery, Loretto Heights College, Denver (November 10–December 5).

1979

Solo exhibition: American Hand, Washington, D.C. (March 18–25).

Group exhibition: *A Century of Ceramics in the United States: 1878–1978*, Everson Museum of Art, Syracuse (May 5–September 23). Catalogue.

Group exhibition: *West Coast Clay Spectrum*, Security Pacific Bank, Los Angeles (June 25–September 2). Catalogue.

Group exhibition: *Ceramics—Six Artists*, Vanguard Gallery, Los Angeles (October 27–November 17).

Group exhibition: *Goldenwest Ceramic Invitational*, Goldenwest College Art Gallery, Huntington Beach, California (November 26–December 21).

1980

Group exhibition: *Making It in Clay—3*, American Hand, Washington, D.C. (January 12–19).

Group exhibition: *Celadon*, Mandell Gallery, Los Angeles (January 15–February 15).

Group exhibition: *Exotic Objects*, Saddleback College Art Gallery, Mission Viejo, California (January 24–February 15).

Group exhibition: *Recent Work in Clay, Glass, Metal, Fiber, and Wood from Southern California*, California State College at San Bernardino Art Galleries (February 11–March 12).

Group exhibition: *American Porcelain: New Expressions in an Ancient Art*, Renwick Gallery, Smithsonian Institution, Washington, D.C. (November 7, 1980–August 16, 1981). Catalogue.

Solo exhibition: American Hand, Washington, D.C. (November 9–13).

1981

Group exhibition: *Made in LA: Contemporary Crafts '81*, Craft and Folk Art Museum, Los Angeles (January 28–April 12). Catalogue.

Group exhibition: *The Animal Image: Contemporary Objects and the Beast*, Renwick Gallery, Smithsonian Institution, Washington, D.C. (March 13–August 30). Catalogue.

Group exhibition: *The Bowl Show*, American Hand, Washington, D.C. (September 13–18).

Group exhibition: *In the Deco Spirit*, Garth Clark Gallery, Los Angeles (December 5, 1981–January 5, 1982).

1982

Group exhibition: *Made in LA: Contemporary Crafts '81*, Federal Reserve Board Galleries, Washington, D.C. (January 15–March 17). Catalogue.

Solo exhibition: American Hand, Washington, D.C. (January 17–22).

Group exhibition: *Pacific Currents/Ceramics 1982*, San Jose Museum of Art, San Jose, California (March 25–April 25). Catalogue.

Group exhibition: *Seventh Ceramics Invitational*, Sykes Gallery, Millersville State College, Millersville, Pennsylvania (April 21–May 7).

Group exhibition: *Art and/or Craft: USA and Japan*, Kanazawa Museum of Art, Japan (September 4–23). Catalogue.

Solo exhibition: *Adrian Saxe: Between Sèvres and Momoyama*, Garth Clark Gallery, Los Angeles (November 13–December 4). Note: This exhibition was also presented at the Everson Museum of Art, Syracuse, in 1983.

Group exhibition: *Transfigured Surfaces*, Brentwood Gallery, St. Louis.

1983

Solo exhibition: Thomas Segal Gallery, Boston (April 9–May 4).

Solo exhibition: American Hand, Washington, D.C. (May 15–June 3).

Group exhibition: *Ceramic Echoes: Historical References in Contemporary Ceramics*, The Contemporary Art Society/Nelson-Atkins Museum of Art, Kansas City (October 14–November 27). Catalogue.

Solo exhibition: *Adrian Saxe: New Raku and Porcelain Works*, Garth Clark Gallery, New York (November 15–December 10).

1984

Group exhibition: *Contemporary Ceramic Vessels: Two Los Angeles Collections*, Baxter Art Gallery, California Institute of Technology, Pasadena (January 4–29). Brochure.

Group exhibition: *Clay Today*, Thomas Segal Gallery, Boston (April 7–May 2).

Group exhibition: *Art in Clay: 1950s to 1980s in Southern California; Evolution, Revolution, Continuation*, Municipal Art Gallery, Los Angeles (July 24–August 26). Catalogue.

Group exhibition: *Masterworks*, Garth Clark Gallery, Los Angeles (September 7–29).

1985

Solo exhibition: *Adrian Saxe: Since Sèvres—New Works*, Garth Clark Gallery, New York (March 12–April 13).

Group exhibition: *Santa Monica Clay Invitational*, Santa Monica College Gallery (April 19–May 18).

Group exhibition: *The Vessel and Its Metaphor: Southern California Ceramics, 1950–1985*, Los Angeles County Museum of Art/Pacific Design Center (July 1–November 15).

Group exhibition: *Clay: Everyday Plus Sunday*, John Michael Kohler Arts Center, Sheboygan, Wisconsin (September 15–December 30).

Solo exhibition: *Adrian Saxe: Porcelain from Sèvres, with Light*, American Hand, Washington, D.C. (September 22–October 11).

Solo exhibition: *Adrian Saxe: New Work*, Garth Clark Gallery, Los Angeles (November 2–December 4).

Group exhibition: *Teapots: Stanford M. Besser Collection of Contemporary Ceramic Teapots*, Arkansas Art Center, Decorative Arts Museum, Little Rock (November 3–December 1). Brochure.

Group exhibition: *Pacific Connections*, Los Angeles Institute of Contemporary Art (November 19–December 21). Catalogue.

Group exhibition: *Thirteenth Chuichi International Exhibition of Ceramic Arts*, Museum of Nagoya, Japan.

Group exhibition: *Twentieth-Century American Ceramics*, Museo de Cerámica, Barcelona, and Museum of Art, Madrid.

Group exhibition: *Selection '85*, American Craft Museum, New York.

1986

Group exhibition: *Contemporary Ceramics*, Muscarelle Museum of Art, College of William and Mary, Williamsburg, Virginia (April 19–June 1).

Group exhibition: *International Contemporary Ceramics Salon*, Garth Clark Gallery at Smith's Gallery, Covent Garden, England (May 8–17).

Group exhibition: *American Potters Today*, Victoria and Albert Museum, London (May 14–August 31). Catalogue.

Group exhibition: *New Clay*, University Art Gallery, California State University, San Bernardino (October 2–30).

Group exhibition: *Teaching Artists: The UCLA Faculty of Art and Design*, Wight Art Gallery, University of California, Los Angeles (October 7–November 9). Catalogue.

Group exhibition: *Craft Today: Poetry of the Physical*, American Craft Museum, New York (October 26, 1986–March 22, 1987). Catalogue.

1987

Group exhibition: *Quatre américains à la Manufacture de Sèvres*, American Center, Paris (January 23–March 21). Catalogue.

Group exhibition: *Homage— 1986 NEA Artist's Fellowship Recipients*, Garth Clark Gallery, Los Angeles (February 7– March 4).

Solo exhibition: University of Missouri-Kansas City Gallery of Art (March 29–April 24). Catalogue.

Group exhibition: *Contemporary Ceramics from the Smits Collection*, Los Angeles County Museum of Art (April 2– July 19). Brochure.

Group exhibition: *American Ceramics Now: The Twenty-Seventh Ceramic National Exhibition*, Everson Museum of Art, Syracuse (April 8– June 28). Catalogue.

Group exhibition: *What's New? American Ceramics since 1980: The Alfred and Mary Shands Collection*, The JBSpeed Art Museum, Louisville (June 16–August 9). Catalogue.

Group exhibition: *All Fired Up*, Beckstrand Gallery, Palos Verdes Art Center, Rancho Palos Verdes, California (September 18–October 31).

Solo exhibition: Garth Clark Gallery, New York (November 10–December 12).

Group exhibition: *Fired with Enthusiasm*, Campbell Museum, Camden, New Jersey (November–December).

1988

Group exhibition: *L'Atelier Experimental de Recherche et de Création de la Manufacture Nationale de Sèvres: 1982–87*, Hall du Centre National des Arts Plastiques, Paris (January 6–29). Catalogue.

Group exhibition: *Triptych*, Garth Clark Gallery, Los Angeles (January 9–February 3).

Group exhibition: *Containers*, Sharon Truax Fine Art, Venice, California (May 13– June 10).

Group exhibition: *Chinese Influence on the American West Coast Contemporary Art*, Taiwan Museum of Art, Taipei (June 26–September 25). Catalogue.

Group exhibition: *East-West Contemporary Ceramics Exhibition: Seoul Olympic Arts Festival*, Korean Culture and Arts Foundation, Seoul (September 10–October 9). Catalogue.

Group exhibition: *Art against AIDS Los Angeles*, Murray Feldman Gallery, Pacific Design Center, Los Angeles (December 14, 1988–February 5, 1989). Catalogue.

1989

Group exhibition: *Kansas City Collects Contemporary Ceramics*, Nelson-Atkins Museum of Art, Kansas City (January 28– March 12). Catalogue.

Group exhibition: *Clay from Plaster*, Kansas City Art Institute Galleries (March 8–11).

Group exhibition: *American Clay Artists 1989*, The Clay Studio in cooperation with the Port of History Museum, Philadelphia (April 1–June 4). Catalogue.

Group exhibition: *American Ceramic Art: The Vessel 1940 to Present*, Pine Street Lobby Gallery, San Francisco (April 10–June 22).

Group exhibition: *Metiers d'Art: L'Europe des céramistes*, Centre Culturel de l'Yonne; Abbaye Saint-Germain, Auxerre, France (April 30–August 28).

Solo exhibition: *Adrian Saxe: Ceramic Sculpture*, Garth Clark Gallery, Los Angeles (May 6–31).

Group exhibition: *The Vessel: Studies in Form and Media*, Craft and Folk Art Museum, Los Angeles (May 10–June 25).

Group exhibition: *Fragile Blossoms, Enduring Earth: The Japanese Influence on American Ceramics*, Everson Museum of Art, Syracuse (May 18–August 27). Catalogue.

1990

Group exhibition: *Words and Volumes*, Garth Clark Gallery, New York (March 6–April 7).

Group exhibition: *Tea for Two*, Pine Street Lobby Gallery, San Francisco (April 2–June 7).

Group exhibition: *American Ceramics*, Gallery Koyanagi, Ginza Chuo-ku, Tokyo (April 20–May 17).

Group exhibition: *Building a Permanent Collection: A Perspective on the 1980s*, American Craft Museum, New York (August 8–September 30).

Group exhibition: *Art that Works: The Decorative Arts of the Eighties, Crafted in America*, Art Services International, Alexandria, Virginia/Mint Museum of Art, Charlotte, North Carolina (August 19–October 7, 1990). Catalogue.

Solo exhibition: Garth Clark Gallery, New York (October 9–November 3).

Group exhibition: *Vessels: From Use to Symbol*, American Craft Museum, New York (November 15, 1990–January 27, 1991). Brochure.

1991

Solo exhibition: Garth Clark Gallery, Kansas City (April 6–May 17).

Group exhibition: *Metamorphosis of Contemporary Ceramics: The International Exhibition of Contemporary Ceramics*, Museum of Contemporary Ceramic Art, Shigaraki Ceramic Cultural Park, Shigaraki, Japan (April 20–May 26). Catalogue.

Group exhibition: *The Anniversary Show: In Praise of the Gallery Pot*, Garth Clark Gallery, Los Angeles (September 7–October 2).

Solo exhibition: Garth Clark Gallery, Los Angeles (November 2–27).

Group exhibition: *Rituals of Tea*, Garth Clark Gallery, New York (December 3, 1991–January 4, 1992) and Los Angeles (December 7–31).

1992

Group exhibition: *Contemporary Ceramic Art*, Museum of Contemporary Ceramic Art, Shigaraki Ceramic Cultural Park, Shigaraki, Japan (January), and Seibu Department Store, Tokyo (February).

Group exhibition: *California Legacy: Concepts in Clay*, FHP Hippodrome Gallery, Long Beach, California/ Beckstrand Gallery, Palos Verdes Art Center, Rancho Palos Verdes, California (February 20–April 25).

Solo exhibition: Garth Clark Gallery, New York (November 4–December 5).

Select Bibliography

NOTE: *All sources in this bibliography mention Adrian Saxe and/or his work. Inclusive page numbers are provided for periodical articles when the entire article is about the artist and/or his work; otherwise only the page numbers where the artist and/or his work are mentioned are listed.*

Books

Axel, Jan, and Karen Mc-Cready. *Porcelain: Traditions and New Visions.* New York: Watson-Guptill, 1981.

Clark, Garth. *American Ceramics: 1876 to the Present.* New York: Abbeville Press, 1987.

————. *The Eccentric Teapot: Four Hundred Years of Invention.* New York: Abbeville Press, 1989.

Dormer, Peter. *The New Ceramics: Trends and Traditions.* New York: Thames and Hudson, 1986.

Levin, Elaine. *The History of American Ceramics: 1607 to the Present.* New York: Harry N. Abrams, 1988.

Lynn, Martha Drexler. *Clay Today: Contemporary Ceramists and Their Work.* Los Angeles/San Francisco: Los Angeles County Museum of Art/Chronicle Books, 1990.

Mayer, Barbara. *Contemporary American Craft Art: A Collector's Guide.* Layton, Utah: Gibbs M. Smith, 1988.

Pearson, Katherine. *American Crafts: A Source Book for the Home.* New York: Stewart, Tabori & Chang, 1983.

Perry, Barbara, ed. *American Ceramics: The Collection of Everson Museum of Art.* New York: Rizzoli, 1989.

Peterson, Susan. *The Craft and Art of Clay.* Englewood Cliffs, New Jersey: Prentice-Hall, 1992.

Exhibition Catalogues

American Ceramics Now: The Twenty-Seventh Ceramic National Exhibition. Syracuse: Everson Museum of Art, 1987.

American Clay Artists 1989. Philadelphia: The Clay Studio in cooperation with the Port of History Museum, 1989.

Art against AIDS Los Angeles. Los Angeles: American Foundation for AIDS Research/Murray Feldman Gallery, Pacific Design Center, 1988.

L'Atelier Experimental de Recherche et de Création de la Manufacture Nationale de Sèvres: 1982–87. Paris: Hall du Centre National des Arts Plastiques, 1988.

California Design Eleven. Pasadena: Pasadena Art Museum, 1971.

Clark, Garth, ed. *Ceramic Echoes: Historical References in Contemporary Ceramics.* Kansas City: The Contemporary Art Society, 1983.

Clark, Garth, and Margie Hughto. *A Century of Ceramics in the United States: 1878–1978.* New York: E. P. Dutton in association with the Everson Museum of Art, 1979.

Clark, Garth, and Oliver Watson. *American Potters Today.* London: Victoria and Albert Museum, 1986.

Contemporary Ceramic Art: Canada, USA, Mexico and Japan. Kyoto: The National Museum of Modern Art, 1971.

Deschamps, Madeleine. *Quatre américains à la Manufacture de Sèvres.* Paris: American Center, 1987.

East-West Contemporary Ceramics Exhibition: Seoul Olympic Arts Festival. Seoul: Korean Culture and Arts Foundation, 1988.

Foley, Suzanne, and Sherri Warner. *Pacific Currents/Ceramics 1982.* San Jose, California: San Jose Museum of Art, 1982.

Glasgow, Lukman. *Ceramic Conjunction.* Long Beach, California: Long Beach Museum of Art, 1977.

Herman, Lloyd E. *American Porcelain: New Expressions in an Ancient Art.* Forest Grove, Oregon: Timber Press, 1980.

————. *Art that Works: The Decorative Arts of the Eighties, Crafted in America.* Seattle: University of Washington Press, 1990.

Inui, Yoshiaki, ed. *Metamorphosis of Contemporary Ceramics: The International Exhibition of Contemporary Ceramics.* Shigaraki, Japan: Museum of Contemporary Ceramic Art, Shigaraki Ceramic Cultural Park, 1991.

Johnston, Phillip M. *Kansas City Collects Contemporary Ceramics.* Kansas City: Nelson-Atkins Museum of Art, 1989.

Kester, Bernard. *Made in LA: Contemporary Crafts '81.* Los Angeles: Craft and Folk Art Museum, 1981.

————. *Made in LA: Contemporary Crafts '81* (adapted for the Federal Reserve Board Galleries, Washington, D.C.). Washington, D.C.: Board of Governors of the Federal Reserve System, 1982.

Levin, Elaine. *West Coast Clay Spectrum.* Los Angeles: Security Pacific Bank, 1979.

Monroe, Michael W. *The Animal Image: Contemporary Objects and the Beast.* Washington, D.C.: Smithsonian Institution Press, 1981.

Morrin, Peter, ed. *What's New? American Ceramics since 1980: The Alfred and Mary Shands Collection.* Louisville: The JBSpeed Art Museum, 1987.

Muchnic, Suzanne, et al. *Chinese Influence on the American West Coast Contemporary Art.* Taipei: Taiwan Museum of Art, 1988.

Nakamura, Kimpei, and Sherri Warner. *Art and/or Craft: USA and Japan.* Kanazawa, Japan: Hokuriku Broadcasting Co., Ltd., 1982.

Perry, Barbara Stone. *Fragile Blossoms, Enduring Earth: The Japanese Influence on American Ceramics.* Syracuse: Everson Museum of Art, 1989.

Sheinbaum, Betty Warner, ed. *Art in Clay: 1950s to 1980s in Southern California; Evolution, Revolution, Continuation.* Los Angeles: Municipal Art Gallery, 1984.

Smith, Paul J., and Edward Lucie-Smith. *Craft Today: Poetry of the Physical.* New York: Weidenfeld & Nicholson, 1986.

Smith, Tobi, ed. *Pacific Connections.* Los Angeles: Los Angeles Institute of Contemporary Art, 1985.

Subler, Craig Allen, ed. *Adrian Saxe.* Kansas City: University of Missouri-Kansas City Gallery of Art, 1987.

Tonelli, Edith, ed. *Teaching Artists: The UCLA Faculty of Art and Design.* Los Angeles: Wight Art Gallery, University of California, 1986.

Newspapers and Periodicals

Apikian, Nevart. "Saxe Views His Art as an Essay." *Syracuse Herald-Journal,* 24 January 1983.

"Art, Money and the NEA." *Ceramics Monthly* 35, no. 2 (February 1987): 46, no. 6.

Ashbery, John. "Feelin' Grueby." *New York* 13, no. 11 (17 March 1980): 57.

Bettleheim, Judith. "Pacific Connections." *American Craft* 46, no. 2 (April/May 1986): 43, 47, 49.

Bizot, Robert. "Métiers d'art: L'Europe des céramistes." *Revue publiee par la societe d'encouragment aux métiers d'art,* no. 38 (May 1989): 64–65.

Blake, Harriet L. "Etcetera." *Washington Post,* 17 January 1982, Living section.

Canavier, Elena Karina. "Art: Feats of Clay." *Coast* 14, no. 12 (December 1973): 15.

Caruso, Laura. "Art Journal: Adrian Saxe." *The Kansas City Star,* 21 April 1991, Arts section.

Chayat, Sherry. "Saxe Jar Purchased for Everson Museum." *Syracuse Herald American,* 28 June 1987, Stars magazine.

Clark, Garth. "Adrian Saxe: An Interview." *American Ceramics* 1, no. 4 (Fall 1982): 22–29.

———. "Adrian Saxe: Between Sèvres and Momoyama." *Everson Museum of Art Bulletin* (January/February 1983): 2.

———. "American Ceramics." *Crafts*, no. 80 (May/June 1986): 47.

Clothier, Peter. "Eli Broad: A Cool Head about Hot Art." *ARTnews* 87, no. 1 (January 1988): 145.

Collins, Amy Fine. "Adrian Saxe at Garth Clark." *Art in America* 76, no. 3 (March 1988): 148–49.

Donohoe, Victoria. "Soup Tureens." *Ceramics Monthly* 36, no. 7 (September 1988): 34.

Dunham, Judith L. "Made in LA/Contemporary Crafts '81." *American Craft* 41, no. 1 (February/March 1981): 18.

Engram, Sara. "Pottery: From Kitchen Table to Museum Pedestal." *Baltimore Sun*, 14 August 1983, Sun magazine.

Forde, Ed. "Exhibitions: Adrian Saxe." *American Ceramics* 2, no. 3 (1983): 64–65.

Gallery. *American Craft* 43, no. 2 (April/May 1983): 70, no. 6.

Gallery. *American Craft* 47, no. 2 (April/May 1987): 78, no. 5.

Girard, Sylvia, and Francoise Espagnet. "L'Atelier Experimental de Recherche et de Création de la Manufacture Nationale de Sèvres." *La revue de la céramique et du verre*, no. 21 (March/April 1985): xx.

Harney, Andy Leon. "Washington, D.C." *Craft Horizons* 33, no. 6 (December 1973): 48.

Huneven, Michelle. "Rare and Well-done: Contemporary California Ceramics and Classic Craftsman Furniture." *L.A. Style* 4, no. 5 (October 1988): 171.

Hunt, William. "Porcelain." *Ceramics Monthly* 25, no. 7 (September 1977): 58.

———. "West Coast Clay Spectrum." *Ceramics Monthly* 28, no. 1 (January 1980): 40–42.

Huntingford, John. "The Critic's Eye." *Crafts*, no. 101 (November/December 1989): 20–21.

Hurst, Brenda. "Exhibitions; Los Angeles." *Craft International* (January/February/March 1986): 43–44.

———. "Playing with Clay at Santa Monica College." *Santa Monica Evening Outlook*, 26 April 1985.

Ianco-Starrels, Josine. "Art News." *Los Angeles Times*, 22 July 1984, Calendar section.

Kester, Bernard. "Letter from Los Angeles." *Craft Horizons* 32, no. 6 (December 1972): 52.

Kester, Bernard, and Susan Peterson. "Letter from Los Angeles." *Craft Horizons* 30, no. 3 (May/June 1970): 65.

Knight, Christopher. "Artist's Vessels Sail on a Revolutionary Sea." *Los Angeles Herald Examiner*, 10 November 1985, Style section.

———. "The Global Potter." *Los Angeles Times*, 24 November 1991, Calendar section.

———. "L.A., Lately." *Elle* 5, no. 4 (December 1989): 190.

———. "Saxe's Four-Part Harmony." *Los Angeles Herald Examiner*, 26 May 1989, Weekend section.

Levin, Elaine. "Homage to Celadon." *Artweek* 11, no. 4 (2 February 1980): 4.

Malarcher, Patricia. "An Interview with Ulysses Dietz." *American Ceramics* 8, no. 2 (1990): 42.

"The Matter Is Clay." *Connoisseur* 218, no. 914 (March 1988): 54.

Mays, John Bentley. "Stylistic Ensembles." *American Craft* 47, no. 5 (October/November 1987): 42–49.

McCloud, Mac [Malcolm McClain, pseud.]. "A History of Clay." *Artweek* 18, no. 25 (11 July 1987): 4.

McKirdy, Kristin. "Adrian Saxe: Céramiste californien." *La revue de la céramique et du verre*, no. 50 (January/February 1990): 30–35.

Monroe, Michael. "A Museum View." *The Studio Potter* 18, no. 1 (December 1989): 30.

Muchnic, Suzanne. "Chinese Influence on American West Coast Contemporary Art." *ArtSphere* 1, no. 1 (1989): 5.

———. "Clay Out West at Security Pacific." *Los Angeles Times*, 14 August 1979.

Nash, Ed. "Ed Nash and the American Hand: An Interview." *The Studio Potter* 16, no. 2 (June 1988): 84–85.

"National Endowment for the Arts Visual Artists Fellowships 1986." *American Craft* 46, no. 6 (December 1986/January 1987): 22.

Nichols, Sarah. "Contemporary Ceramics and the Vessel Aesthetic." *Carnegie Magazine* 58, no. 1 (January/February 1986): 31–32, 36.

Pagel, David. "Adrian Saxe's Sexy Pots." *Art Issues*, no. 26 (January/February 1993): 16–18.

Perrone, Jeff. "More Sherds: Breaking the Silence." *American Ceramics* 4, no. 4 (1986): 34.

————. "Porcelain and Pop." *Arts Magazine* 58, no. 7 (March 1984): 80–82.

Piché, Thomas. "Saxe's Ceramics Combine Art Theory with Pottery Ideas." *Syracuse Herald American*, 13 February 1983, Stars magazine.

Pincus, Robert L. "The Galleries." *Los Angeles Times*, 26 November 1982, Calendar section.

Plagens, Peter. "Schjeldahl Demystified." *Journal: A Contemporary Art Magazine*, no. 31 (Winter 1981): 27.

Reed, Rochelle. "Best Bets." *New West* 5, no. 2 (28 January 1980): SC-20.

Rickford, H. Dieter. "New Art." *Sunburn/Fogbound* 1, no. 1 (1986): 15.

Rogers, Patsy. "High Craft: When Pottery Is Art." *Washington Star*, 1 March 1981, Home-Life magazine.

Rubenfeld, Florence. "Adrian Saxe." *New Art Examiner* 13, no. 4 (December 1985): 54.

————. "American Hand." *American Craft* 41, no. 1 (February/March 1981): 40–41.

Rubin, Michael G. "New Pottery at Brentwood." *St. Louis Globe-Democrat*, 1–2 January 1983.

Russell, John. "The Cooper-Hewitt Displays More of Its Design Trove." *New York Times*, 6 September 1991.

Save, C., and V. Morlot. "Quatre américains à Sèvres." *L'Atelier des métiers d'art*, no. 115 (February 1987): 27–31.

Schjeldahl, Peter. "L.A. Demystified." *Journal: A Contemporary Art Magazine*, no. 31 (Winter 1981): 23.

————. "Excellent Pot." *The Village Voice*, 8 December 1992.

Seipp, Catherine. "You Say It's a What?" *Spirit* (December 1989): 46.

————. "A Show of Ceramics at Port of History." *Philadelphia Inquirer*, 20 April 1989.

Stapleton, Constance. "Tomorrow's Antiques." *The Washingtonian* 14, no. 8 (May 1979): 136, 246.

Storie, Laurie J. "The Antelope Artist." *Syracuse Herald-Journal*, 25 January 1983.

Tolone, Zoe. "Moving Forward through the Past." *Syracuse New Times*, 9 February 1983.

"Vessels to Lift or Simply to Look At." *New York Times*, 22 November 1990, Home section.

Weingarten, Toni. "Art News." *Los Angeles Times*, 20 July 1980, Calendar section.

"Westwood Clay National." *Ceramics Monthly* 30, no. 8 (October 1982): 34–37.

Wilson, William. "California Ceramics: Shape of Things to Come." *Los Angeles Times*, 9 August 1984, Calendar section.

Suggested Readings

Alsop, Joseph. *The Rare Art Traditions: The History of Art Collecting and Its Linked Phenomena*. New York: Harper & Row, 1982.

Berger, John. *Ways of Seeing*. London: British Broadcasting Corporation and Penguin Books, 1972.

Burnham, Jack. *Beyond Modern Sculpture: The Effects of Science and Technology on the Sculpture of This Century*. New York: George Braziller, 1968.

Cox, Warren E. *The Book of Pottery and Porcelain*. 2 vols. New York: Crown Publishers, 1944.

Csikszentmihalyi, Mihaly, and Eugene Rochberg-Halton. *The Meaning of Things: Domestic Symbols and the Self*. Cambridge, England: Cambridge University Press, 1981.

Hutcheon, Linda. *The Politics of Postmodernism*. New York: Routledge, 1989.

Kant, Immanuel. *Critique of Judgment*. Translated by J. H. Bernard. New York: Hafner Press, 1951.

Rawson, Philip. *Ceramics*. Philadelphia: University of Pennsylvania Press, 1984.

Risatti, Howard, ed. *Postmodern Perspectives: Issues in Contemporary Art*. Englewood Cliffs, New Jersey: Prentice-Hall, 1990.

Savill, Rosalind. *The Wallace Collection: Catalogue of Sèvres Porcelain*. 3 vols. London: The Wallace Collection, 1988.

Editor: Gregory A. Dobie

Designer: Pamela Patrusky

Photographers: Steve Oliver (LACMA), Dean Beasom, Anthony Cuñha, Bruce White, and John White

Printer: Toppan Printing Company, Ltd., Tokyo

This catalogue was composed on the Macintosh in Monotype Perpetua, with display type in Adobe DINMittelschrift, Adobe Gill Sans, and Bitstream Amazone. It was imageset on a ProSet 9800 by Prepress Studio, Los Angeles.

All exhibitions are the result of the efforts of many people. A special thanks goes to research assistant Jennifer Easton, who organized the early stages of the project and compiled the select bibliography and exhibition history. Jim Collins of Notre Dame University gave the right blend of scholarship and wit to an analysis of Saxe's work. Antoine d'Albis of the Manufacture Nationale de Sèvres shared his knowledge of historical Sèvres pieces and the current workings of the factory. Garth Clark, Mark Del Vecchio, Gretchin Adkins, and Wayne Kuwada were most helpful in tracking down Saxe's works. Ken Deavers of the American Hand Plus, Washington, D.C., served as a great source of early, hard-to-find objects. I am also grateful to the estate of Rick Murphy for letting me see other seminal early works by Saxe.

Los Angeles County Museum of Art volunteers Irene Mitchell and Maggie Omerberg and intern Sherri Birdsong performed countless tasks necessary for the smooth running of an exhibition. Joan Takayama-Ogawa and Elaine Levin were very helpful

Acknowledgments

as well. As with all loan shows, this exhibition would not have been possible without the generous support of those who lent their works.

The Clay Art of Adrian Saxe received a grant from the National Endowment for the Arts. It is gratifying that the NEA chose to support a ceramic artist who works within the decorative arts and vessel traditions. Thanks also go to the Pasadena Art Alliance for its assistance in support of the research aspect of the project.

This exhibition would not have reached fruition without the fine staff at the Los Angeles County Museum of Art, headed by Michael E. Shapiro. Leslie Greene Bowman, curator of decorative arts, and Martin Chapman, associate curator of decorative arts, offered consistent encouragement. Robert Singer, curator of Japanese art, advised me and made several key contacts in Japan to help ensure that the exhibition would travel there. My colleagues June Li and Hollis Goodall-Cristante, assistant curators of Far Eastern and Japanese art, respectively, were most helpful with

insights into Asian ceramics. Mary Levkoff, assistant curator of European sculpture, supplied information about terra-cotta works. Many thanks are owed to Peter Brenner and Steve Oliver of photographic services, Mitch Tuchman and Gregory A. Dobie of publications, and Pamela Patrusky of graphic design for the beauty of the exhibition catalogue. Renée Montgomery and Chandra King of the registrar's office oversaw the many details of procuring the artworks; Art Owens, assistant director of operations, saw to it that they were properly displayed.

Most important to the successful mounting of this exhibition was the ceaseless cooperation and good-heartedness of Adrian and Connie Saxe. Over the several years of this project they provided delicious lunches to punctuate the hearty diet of ideas. This, coupled with the sophistication of Saxe's art, made all of the hard work worthwhile.